A souvenir guide

At Home with Art
Treasures from the Ford Collection
at Basildon Park

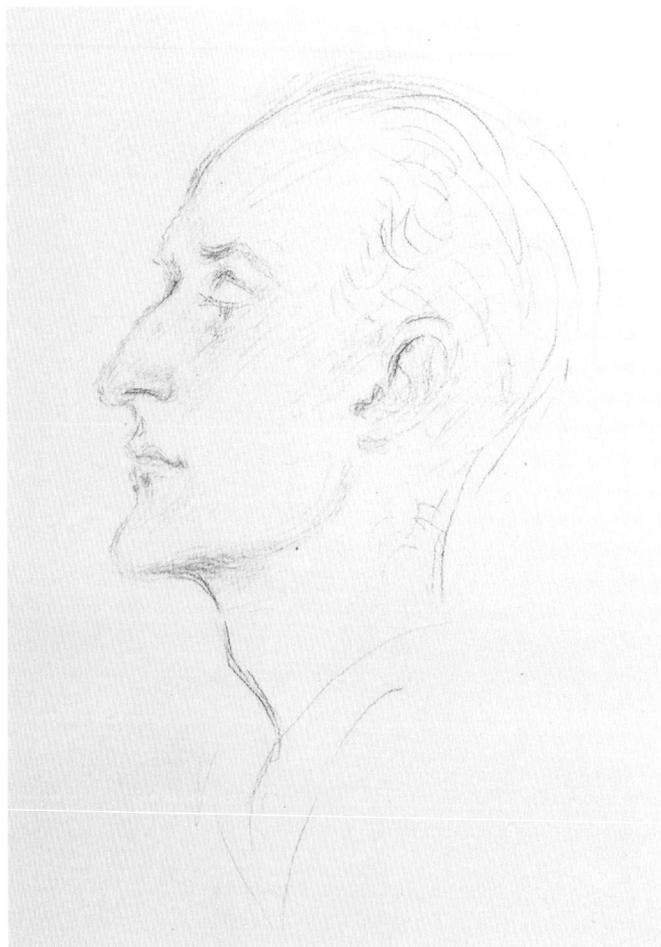

GW01454317

National Trust

At Home with Art

Sir Brinsley Ford was a committed collector of works of art from the age of eleven. At the end of a lifetime of collecting, his collection embraced not only Old Master paintings, but also twentieth-century British pictures, sculpture and decorative arts. He never lost his passion for sharing his art collection with friends and fellow enthusiasts. In much the same way as Lord and Lady Iliffe had been, Sir Brinsley was also a generous benefactor of the National Trust (see p.10).

On his death in 1999, Sir Brinsley's collection was divided between his children. His son Augustine has now very generously agreed to loan more than 60 works from the collection to Basildon Park for a period of at least five years. They will be exhibited in the south pavilion, where they will perfectly complement the eighteenth-century Italian paintings collected by Lord and Lady Iliffe for Basildon. (From 1978, when they gave Basildon to the National Trust, this was the Iliffes' drawing room.)

Highlights include one of Thomas Patch's notorious caricatures of British Grand Tourists enjoying the sculptures of Florence (267120, p.30), and portraits by Pompeo Batoni (267114, p.14) and Anton Raphael Mengs (267117, p.28). This fully illustrated catalogue is published to accompany the exhibition with grateful thanks to Augustine Ford.

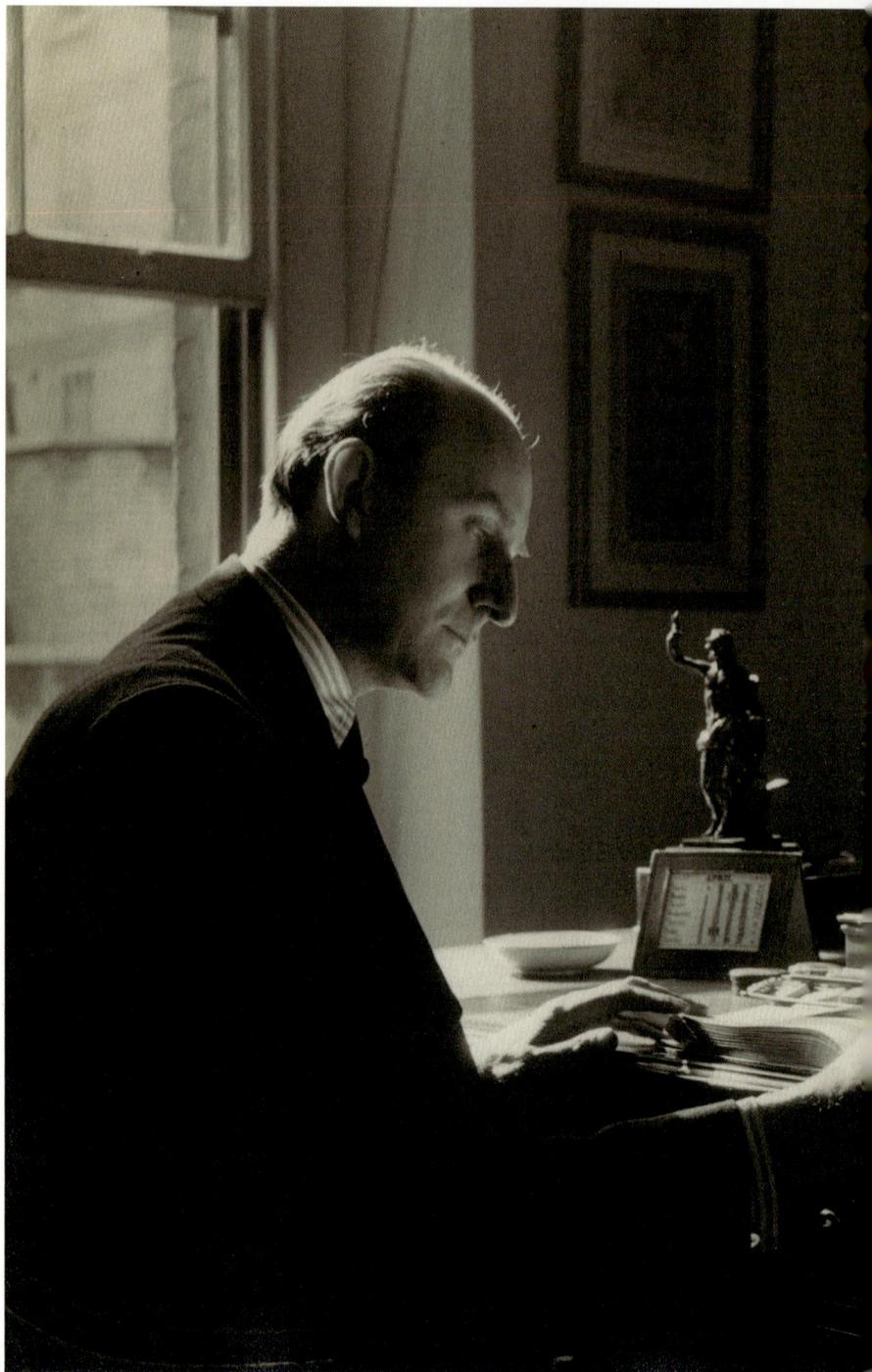

Left Brinsley Ford at his desk in 1952

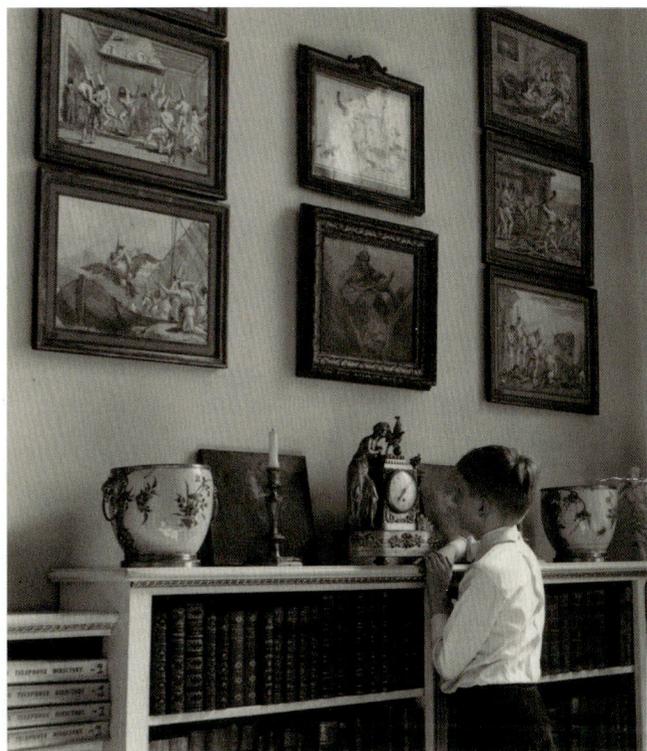

Above Augustine Ford in the Library in 1952

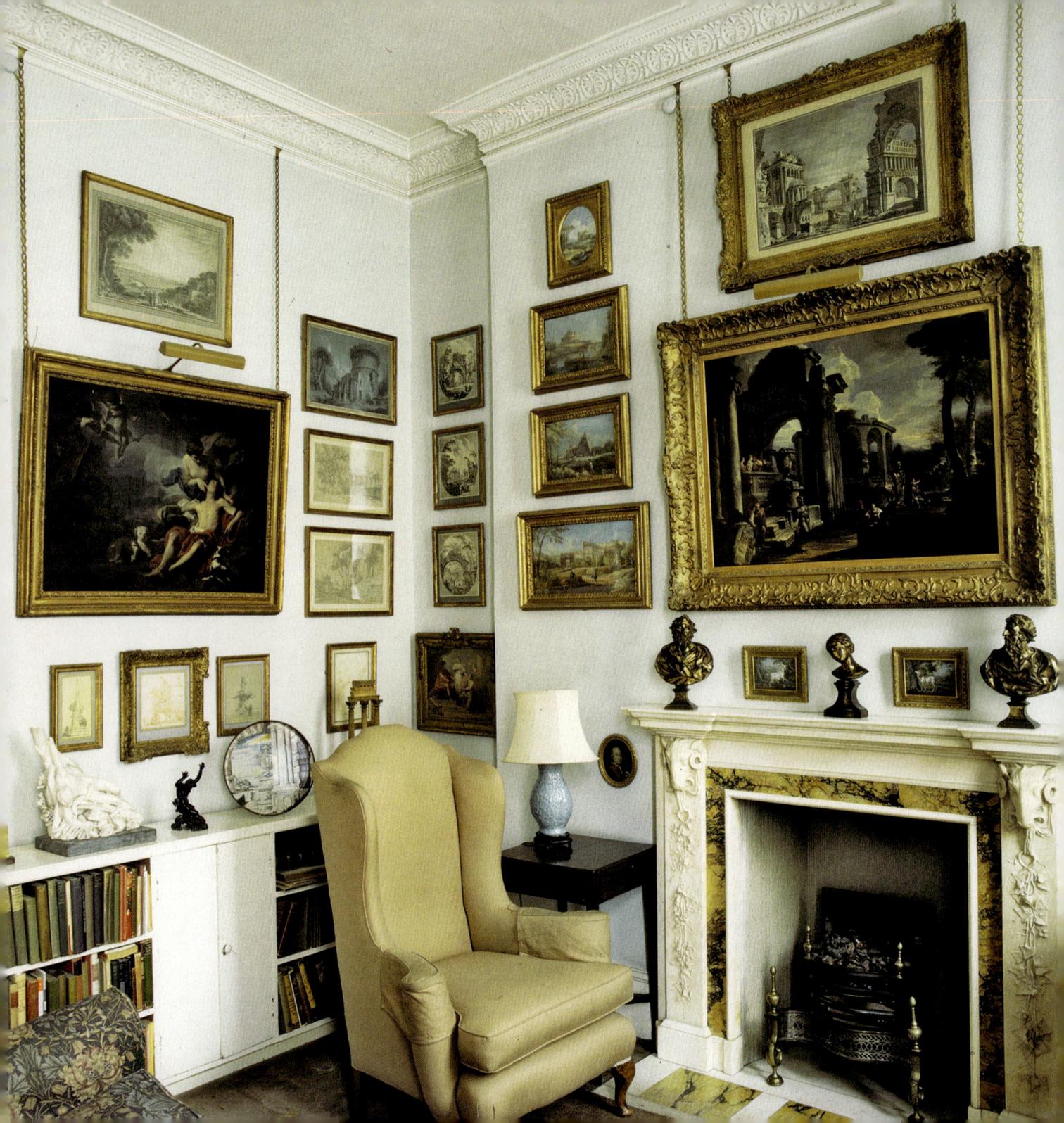

Sir Brinsley Ford (1908–99)
Patron, collector, scholar and benefactor

A tour of Wyndham Place

Before transferring to the Intelligence Corps during the Second World War, Brinsley Ford saw a short period of service in the unlikely guise of Troop Sergeant-Major in an artillery unit. An event he liked to recall from that time was of the puzzling reprimand he received one day from an inspecting colonel – for displaying a nude pin-up. The object of the colonel's disapproval, it turned out, was a photograph Ford had hung over his bunk of Giambologna's *Venus Standing on a Dolphin*, a particular favourite among a group of works by Giambologna contained in Ford's remarkable family collection.

This story – in which Giambologna would invariably be referred to as 'John of Bologna' – was one of a number with which Ford might regale a guest over the glass of montilla that marked the midway point of a tour of the Ford Collection. Another was of how, after James Byam Shaw had successfully bid for Ford in the 1936 Oppenheimer sale on a drawing by Michelangelo, Ford's aunt had given her nephew a stiff dressing-down on the perils of such extravagance (the drawing had cost a little over 3,000 guineas, the price of a good-sized house).

These and other anecdotes, recounted by Ford in a style once described as uniting 'the measured cadences of Edward Gibbon with the humorous sparkle of Horace Walpole', contributed to make a visit to the Ford Collection an outstandingly memorable event. All who have paid a visit to look over the collection at Wyndham Place, and who recall the intense sense of expectancy with which they were led from one treasure-filled room to the next, will also retain a vivid recollection of the spellbinding effect worked on them by their urbane and characterful guide.

Ford once wrote that 'the pleasure of owning a collection, and sharing it with others, fully compensates for the burdens that it entails', and he welcomed scores of enthusiasts through the door of his home. Tours began at 6 o'clock sharp with Ford – tall, distinguished and invariably dark-suited – seated at the head of an ancient table in the dining room. In his sonorous voice Ford would relate the history of the collection from the time of its original formation in the eighteenth century by his ancestor Benjamin Booth; and would explain the different parts played by successive generations of Fords in moulding its present shape.

The collection grew up around a group of pictures by the English landscape artist Richard Wilson, the most important such group in private hands in Booth's day and today. They entered the collection as a result of the marriage of Booth's daughter, Marianne, into the Ford family. Ford used to express the hope that he had done something to redress the balance since the diarist Joseph Farington remarked, 'Lady Ford has got all the pictures by Wilson and says she will not sell any of them, nor will she suffer her house to be dirtied by permitting people to see them.'

Ford was proud of the collection's claim to a continuous presence in London – albeit at different addresses – for two centuries, and of the fact that it is the only such one remaining to be referred to by both Farington and Gustav Friedrich Waagen, in his *Treasures of Art in Great Britain* (1854). He was also justly proud of his own role in supplementing the collection over his

Opposite Lady Ford's Sitting Room in 1998. Busiri's views of Rome flank the chimneypiece

lifetime with a magnificent array of pictures by Old Master and contemporary artists, Renaissance and Baroque sculpture and ceramics. The 60th annual volume of the Walpole Society, whose President Ford had been since 1986, was devoted to the collection.

Before leaving the dining room for the principal rooms on the upper floors of his home, Ford would draw his guests' attention to a variety of eighteenth-century sculptures and paintings, and to an exceptional group of Castelli maiolicas acquired by his great-grandfather Richard Ford, and added to by Ford himself. Visitors would also have the opportunity to inspect a portrait of Benjamin Booth – variously ascribed to Reynolds and Opie – and to admire a splendid group of drawings by Augustus John, including portraits of Ford and his wife, acquired from the artist in the 1940s.

Upstairs, the true extent and the eclectic nature of the collection became apparent. The Renaissance bronzes, Baroque sculpture, French eighteenth-century terracottas and Italian Old Masters for which Ford first developed a taste in the 1930s, were displayed alongside later works by Toulouse-Lautrec, Epstein, Gaudier-Brzeska, Frank Dobson, John Piper, John Bratby and Henry Moore, some of them acquired when Ford was still an undergraduate at Oxford. Room after room of Ford's home testified to his careful stewardship of the family inheritance, and above all to his own sure eye for quality.

The culmination of a tour came when Ford ushered his guests into the great first-floor drawing room, with its breathtaking array of Richard Wilsons, and Michelangelo's celebrated study for the first version of his statue of *The Risen Christ* in the church of Sta Maria sopra Minerva at Rome. Works by Ingres and other masters hung beside them, and on the tables were the models by Giambologna. Also of special interest was a pair of handsomely embroidered slippers presented to Ford on his retirement as Secretary of the Society of Dilettanti.

Two rooms more than any others in Ford's home recalled his great enthusiasms: his bedroom, hung from floor to ceiling with works of the Royal Academy Schools students he regularly acquired; and his cluttered study, powerhouse of his scholarly work and myriad activities in the service of the arts. For the student of Fordiana, the study appeared uncannily to fit Sir William Maxwell-Stirling's description of his ancestor Richard Ford's room with 'the inky table, the crammed pigeon holes, and the piles of manuscripts which encumbered the chairs and the floor'.

Although Ford used to say of himself that he was unable to draw a line, he was a great encourager of fine draughtsmanship in others, and a generous patron. In addition to the quantity of works by young artists he bought over the years, in 1976, with the proceeds of the sale of his first edition of Goya's *La Tauromaquia*, he endowed the annual Richard Ford Award – named after his famous Hispanophile ancestor, author of *The Hand-Book for Travellers in Spain* (1845) – to enable a talented Royal Academy Schools student to go on a week-long study trip to Spain. And 1986 saw the birth of the National Trust Foundation for Art, an organisation formed under Ford's chairmanship to enrich National Trust properties with pictures and sculpture by contemporary artists with especial emphasis on young artists of promise.

It was Ford's fascination with his family and its achievements (his Christian names, Richard Brinsley, derived from his great-great-great-great-grandfather, the playwright Sheridan) that provided probably the greatest impetus to his scholarly activities. His immense pride in his ancestor Richard Ford – to whom he bore a strong physical resemblance and all of whose papers and drawings he inherited – prompted him to mastermind the splendid 1974 exhibition 'Richard Ford in Spain', shown in London and Birmingham in aid of the National Art-Collections Fund, for which he not only

Opposite The Library in 1998. This room was devoted to Venetian art

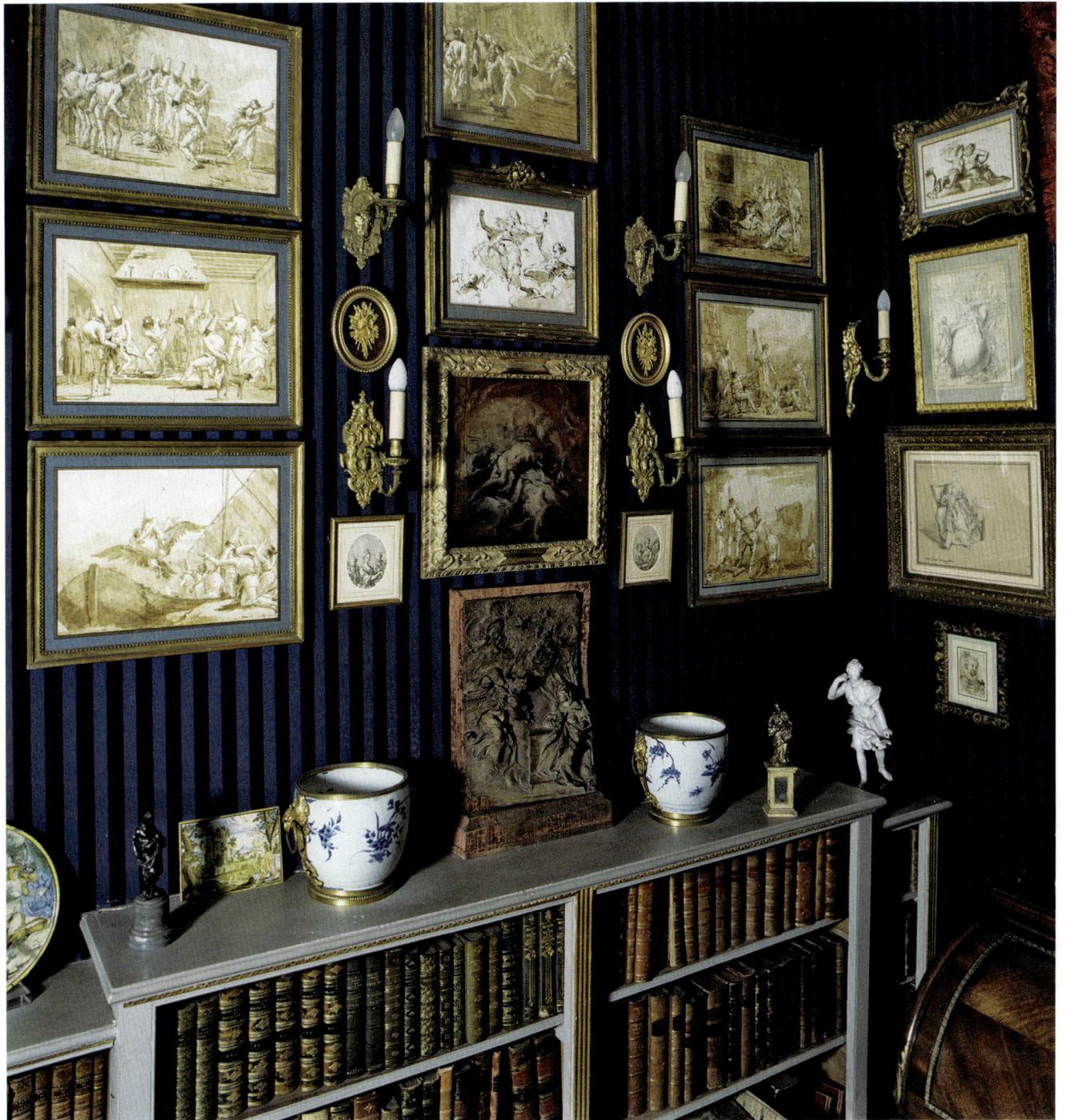

provided all the loans but also wrote the meticulous catalogue.

Equally, it was his deep love of his family collection that led him to produce the model monograph *The Drawings of Richard Wilson* (1951); and his desire to share it with others that resulted in the regular loans from his collection to exhibitions world-wide.

Ford's study of Richard Wilson, in combination with his work on a Walpole Society edition of the letters of the watercolourist Jonathan Skelton, in turn led to an almost consuming interest in the subject of the English in Italy at the time of the Grand Tour. By 1972 he had written some 280,000 words relating to the activities of Englishmen in Rome at that period, and had filled 94 foolscap volumes with notes. This huge archive of material, now housed at the Mellon Centre, provides an invaluable source for scholars – so much so that one book on Pompeo Batoni contains over 100 separate acknowledgements to Ford's researches. The archive forms the basis for John Ingamells's compendious volume, *A Dictionary of British and Irish Travellers in Italy, 1701–1800*, published in 1997.

For nearly 30 years Ford sat on the Executive Committee of the National Art-Collections Fund, of which he had first become a member in 1927. Major works purchased by museums with the NACF's assistance during Ford's chairmanship were a Donatello bronze at the Victoria and Albert Museum, a van Dyck *Madonna and Child* at the Fitzwilliam Museum in Cambridge, and a pair of Stubbs's paintings at the Tate Gallery. For 35 years Ford was a member of the editorial board of *The Burlington Magazine*, to which he made his first erudite contribution in 1939 ('Ingres' Portrait Drawings of English People at Rome, 1806–1820'), and which dedicated an issue in tribute to him on his 80th birthday.

GEORGE IRELAND
Reprinted by permission from *The Independent*, Obituaries, 8 May 1999

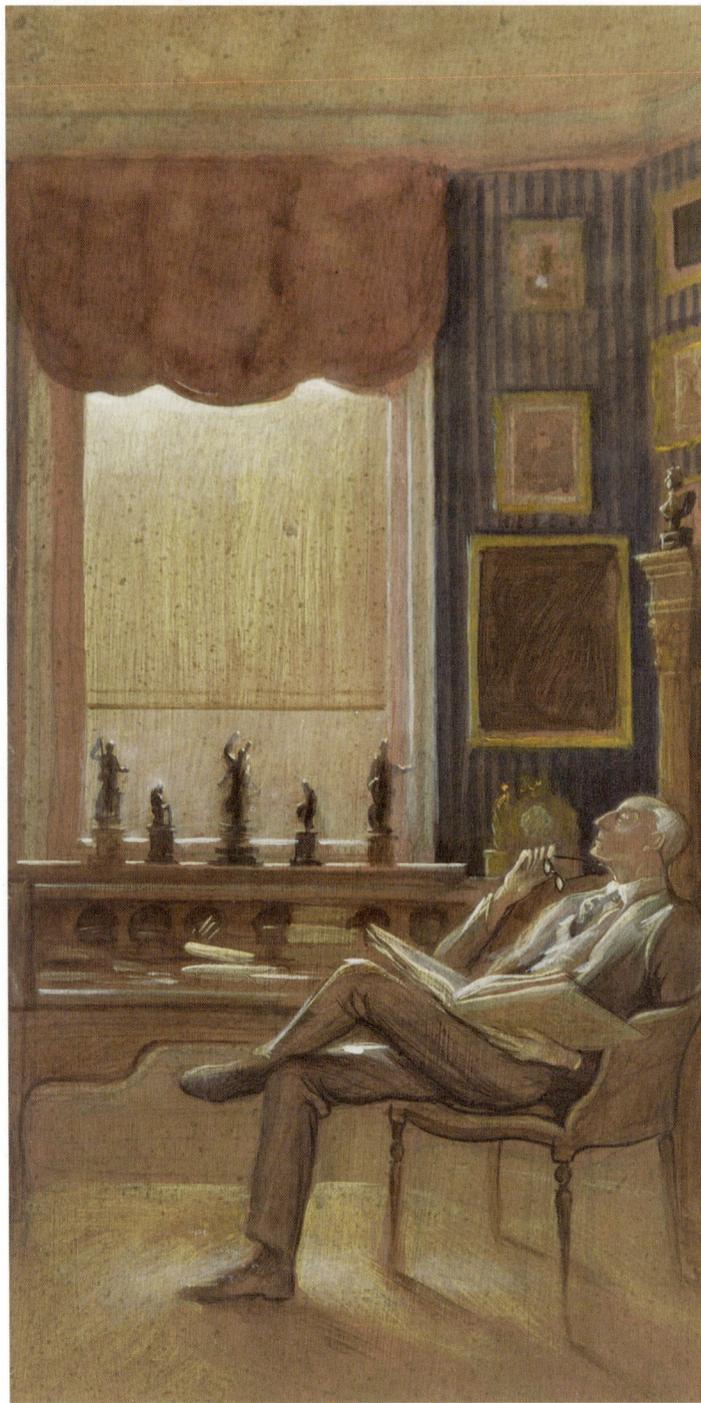

Art at Home

Sir Brinsley Ford and the Iliffes

At first sight, there would not seem to be much in common between Wyndham Place (Sir Brinsley Ford's relatively modest London home) and Basildon Park (the Iliffes' Palladian country house in Berkshire). Moreover, Sir Brinsley had already inherited an important collection of eighteenth-century British landscapes, whereas the Iliffes were having to start from scratch, furnishing an empty and semi-derelict house that had lost not one, but two family picture collections. (They had begun by buying small-scale Barbizon paintings, but soon realised that these were inappropriate for Basildon.)

But in fact, the Ford and the Iliffe collections have many similarities. They were largely put together in the post-war years of austerity, when works of art of the highest quality could be picked up for what now seem to be derisory sums. Sir Brinsley and the Iliffes had similar tastes for seventeenth- and eighteenth-century Italian painting, which was then deeply out of fashion. Leading the revival in interest was Sir Denis Mahon, a scholar-collector in the same mould as Sir Brinsley. During his long life, Mahon particularly championed the seventeenth-century Bolognese painter Guercino through his writing and collecting.

Not surprisingly perhaps, Sir Brinsley and the Iliffes turned to the same dealers for advice: Jim Byam-Shaw and Roddy Thesiger of Colnaghi's, which was the leading firm in this field. Not only did Byam-Shaw and Thesiger supply beautiful paintings at reasonable prices, but they also took great care to choose elegant and appropriate frames for them. This was important, because Sir Brinsley and the Iliffes were not setting out to create a museum, but to furnish a welcoming home. As Gervase Jackson-Stops noted of Sir Brinsley, 'Unlike many connoisseurs, who like to see their works of art in isolation and are suspicious of their decorative effect, he has always had a keen eye for picture-hanging, and the arrangement of the collection is one of its particular delights.' The same could just as easily be said of the Iliffes.

Sir Brinsley and the Iliffes were both collectors of Old Masters and patrons of the new. In the 1930s Sir Brinsley had bought contemporary sculpture, and in his later years he was a great encourager of young artists. He had also helped to set up the National Trust's Foundation for Art (see p.11). Lord Iliffe sat for his portrait to Graham Sutherland, and bought numerous Sutherland studies for the *Christ in Glory* tapestry in Coventry Cathedral, which he gave to the Herbert Art Gallery in that city.

Patronage was combined with public-spiritedness. Sir Brinsley sat on numerous Arts bodies, and enjoyed sharing his collection with others (see p.5). The Iliffes went one step further and in 1978, in an extraordinary act of generosity, gave Basildon and its superb collections to the National Trust so that they could give pleasure to all.

Bearing in mind all their shared interests, it is surprising that Sir Brinsley and the Iliffes did not meet more often. His engagement diaries record only a lunch at Basildon and a return dinner at Wyndham Place in 1985.

Opposite Alec Cobbe, *Brinsley Ford in the Library at Wyndham Place*

Sir Brinsley Ford and the National Trust

by Dudley Dodd

The National Trust was fortunate to count Sir Brinsley Ford among its friends. For a quarter of a century he placed his expertise, wisdom and wit at its disposal on a voluntary basis. In 1971 he was among the founding members of its Arts Panel, in 1980 was appointed Honorary Adviser on Paintings, and served as first chairman of the Trust's Foundation for Art in 1986–90.

It was under Sir Brinsley's leadership of the National Art-Collections Fund (1975–80) that the National Trust became eligible to receive grants. These have fast become a much-sought-after benefit when the Trust raises funds to purchase works of art proven to have belonged to one of its houses.

Between the years 1970 and 1990 land, houses, possessions and members rained down on the Trust as never before. St J. Gore, head of Historic Buildings, and his successor, Martin Drury, introduced professional standards for the curators and conservators. Sir Brinsley certainly applauded their ambition to achieve serious things in light-hearted ways. The happy and productive partnership of the Trust's curators and land agents with (volunteer) members of its committees and panels was a key element in this period of expansion and thrift in the organisation.

The Arts Panel comprised leading art historians and specialists in the fine and decorative arts. It advised on the care and presentation of houses and collections, which in practice meant giving tutorials to the Trust's often young regional staff. During Sir Brinsley's term the Trust acquired further country houses and overhauled several with outstanding works

of art; examples of the latter being Clandon, Dunham Massey, Penrhyn, Petworth and Powis. The Panel was chaired by Lord Norwich and Jim Lees-Milne, who led expeditions to distant country estates often on short winter days to look, inform, argue, sup and joke, on occasions reminiscent of Patch's *ensembles*. Sir Brinsley, always immaculately attired, was as interested in the people he met as in the works of art. Moreover, he was often revisiting houses whose owners he had known, as at Dudmaston, Hinton Ampner, Mottisfont and Felbrigg. The last was a particular favourite on account of the Grand Tour pictures. On Sir Brinsley's last visit to Felbrigg with the Panel, one of those incidents occurred which explain why he so endeared himself to colleagues and the Trust's staff. Stepping back to admire an engraving on a bedroom wall while expounding on it, he missed his footing and toppled back into an enamelled hip bath placed in the centre of the room in a misguided resonance with *Upstairs Downstairs*. Exclamations of alarm from the company evaporated when Sir Brinsley was found unhurt, reclining in the tub and helpless with laughter.

Kingston Lacy was left to the Trust in 1981 with a magnificent collection of pictures then virtually unknown. St J. Gore was a close friend of Sir Brinsley, and they spent many happy weeks studying the collection, cataloguing and overseeing its conservation and presentation. During these years they also served as trustees of the Faringdon Collection at Buscot Park (National Trust). This chimed with Sir Brinsley as patron of contemporary figurative art and his enthusiasm for young artists of that persuasion,

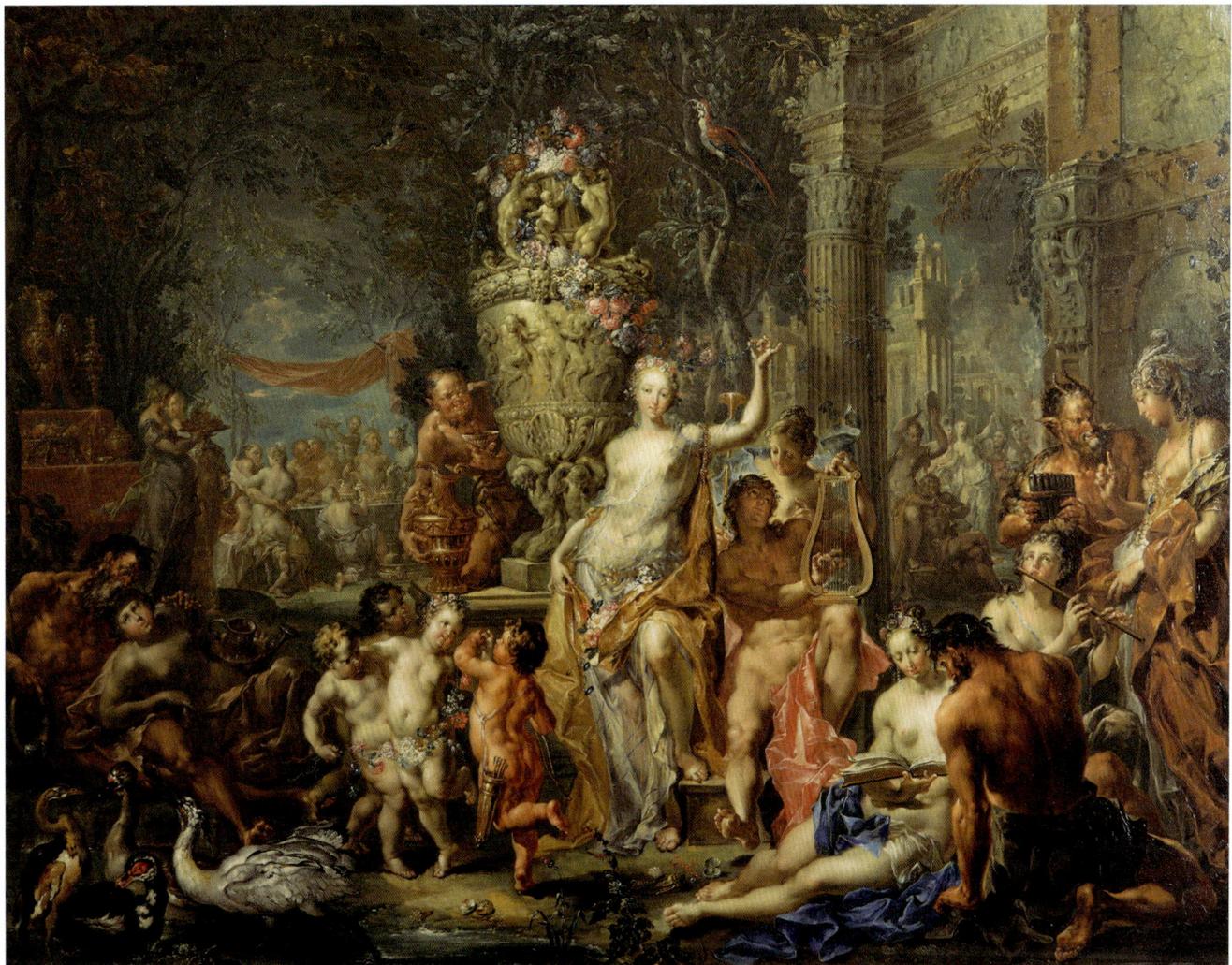

Above Johan Georg Platzer, *The Feast of Flora*

an interest manifest in a long association with the Royal Academy, the City & Guilds of London Art School and his initiative of the Richard Ford Award in 1977.

When in 1985 the National Trust contemplated commissioning artists to record aspects of its properties, Sir Brinsley was the obvious choice as chairman of what became the Foundation for Art. The fledgling venture needed to raise money to fulfil its purpose, and Sir Brinsley persuaded Agnews to hold three exhibitions of pictures for sale by artists selected primarily by himself.

It is remarkable that this patrician of the arts stood at the helm of such an initiative within the National Trust. Living artists – invariably demanding – represented a further strand of his connoisseurship, whose primary focus is represented in the exhibition at Basildon.

Paintings, Drawings and Engravings

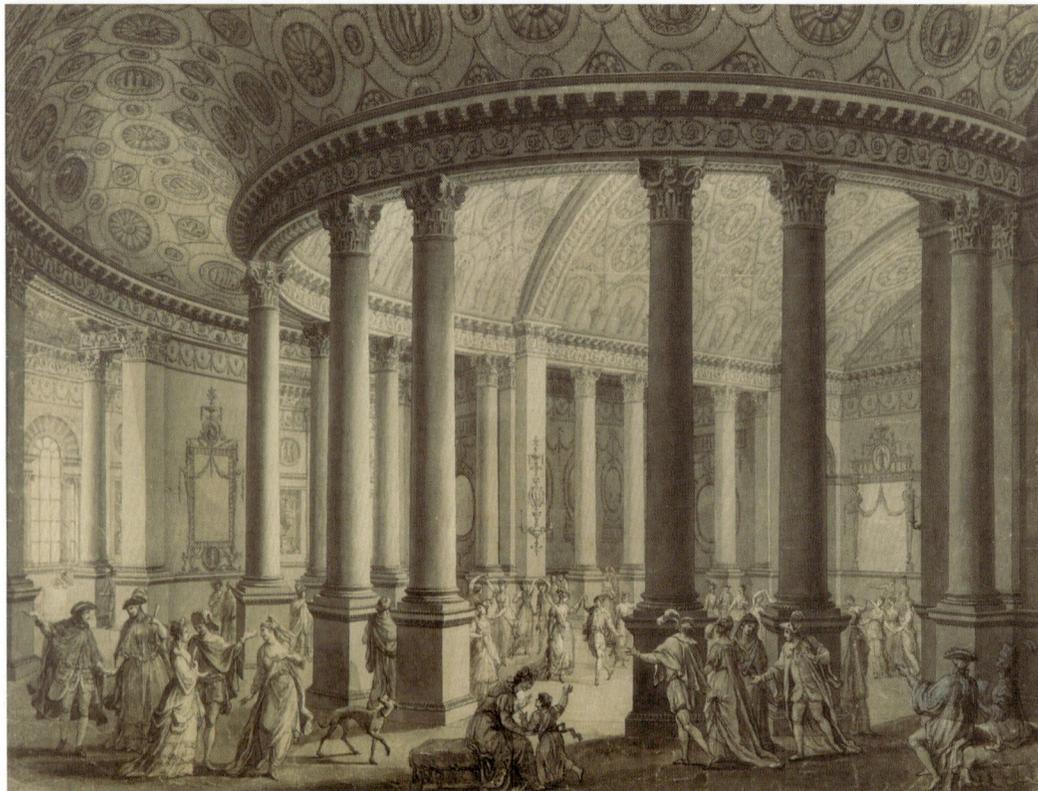

* For further information, see www.nationaltrust collections.org.uk/ object/267153

267153

267153* Attributed to ROBERT ADAM (1728–92) and/or JOSEPH BONOMI (1739–1808)

The Ballroom of a Pavilion erected at the Oaks, Surrey, for a Fête Champêtre given by Lord Stanley on June 9th 1774

Pen and grey wash on paper, 42 × 57.2 cm

The 42,000-square-foot ballroom designed by Adam to celebrate the forthcoming marriage of Lord Stanley to Lady Betty Hamilton was one of the grandest temporary buildings of the eighteenth century. According to Horace Walpole, the party cost Lord Stanley £5,000. Mrs Delany described the occasion: 'The gentlemen and ladies danced on the green till it was dark, and then preceded the musick to the other side of the garden, the company following, where a magnificent saloon had been built, illuminated and decorated with the utmost elegance and proportion: here they danced till supper, when curtains were drawn up, which shewed the supper in a most convenient and elegant apartment'.

Bonomi was Adam's 'best draughtsman and

colourist', and this drawing was probably produced under Adam's supervision by Bonomi, with assistance from other draughtsmen. The drawing probably served as a record of the event for publication.

Robert Adam's more permanent work is well represented among the National Trust's properties, which include Hatchlands Park in Surrey, Kedleston Hall in Derbyshire, Nostell Priory in West Yorkshire, Osterley Park in London, and Saltram in Devon. The ceiling decoration of the Entrance Hall at Basildon Park is derived from *The Book of Ceilings*, which was published by Adam's assistant, George Richardson, in 1776. The ceiling of the Dining Room at Hinton Ampner in Hampshire is copied from Adam's designs for 38 Berkeley Square.

267113 PAOLO ANESI (1697–1773)

A River Landscape, c.1730

Oil on canvas, 39.4 × 47 cm

Anesi was a productive and versatile landscape painter who catered for the tourist market with portable easel paintings like this, and for the locals (such as Cardinal Albani) with decorative schemes. The setting has not been identified, but is probably the outskirts of Rome. A figure in the foreground – possibly a Grand Tourist – is shown surveying the view.

Anesi may also have painted *A View of the Forum, with the Colosseum, S. Francesca Romana, and the Arch of Titus* (Hinton Ampner, Hampshire; NT 1530071).

267113

267114 POMPEO BATONI (1708–87)

Humphry Morice (1723–85), 1761–2

Oil on canvas, 117.5 × 172.8 cm

Morice was on his first tour of Italy in 1760–2, when he was painted resting after a day's shooting with his hounds. (Morice was an animal lover, who left £600 in his will for his horses and hounds.) Two towers in the Vatican gardens are visible in the background. Unlike many Grand Tourists, Morice had come to Italy for the sake of his health. Horace Walpole, who was a mutual friend of John Chute of The Vyne (NT), called him 'puny and precious'. Despite this, Morice was an energetic and discerning collector of landscapes by Poussin, Claude and Canaletto, which he displayed in his home near Chiswick. He spent most of his later years in Italy, dying in Naples, where he had gone seeking a cure for his gout.

Batoni was the leading portrait painter in Rome in the second half of the eighteenth century, and was much sought after by Grand Tour visitors. There is a long tradition of depicting figures reclining in a landscape, often in a melancholy attitude. However, this pose is unique in Batoni's work, who more usually painted his sitters in a vertical format. The pose (in reverse) was used most famously in Johann Tischbein's *Goethe in the Roman Campagna*, 1786–7 (Städel Museum, Frankfurt). It may also have inspired Hugh Douglas Hamilton's *4th Earl of Bristol*, 1790 (Ickworth, Suffolk; NT 851985).

Batoni also painted religious subjects, which are well represented at Basildon Park by *God the Father* (NT 266910) and seven of the disciples.

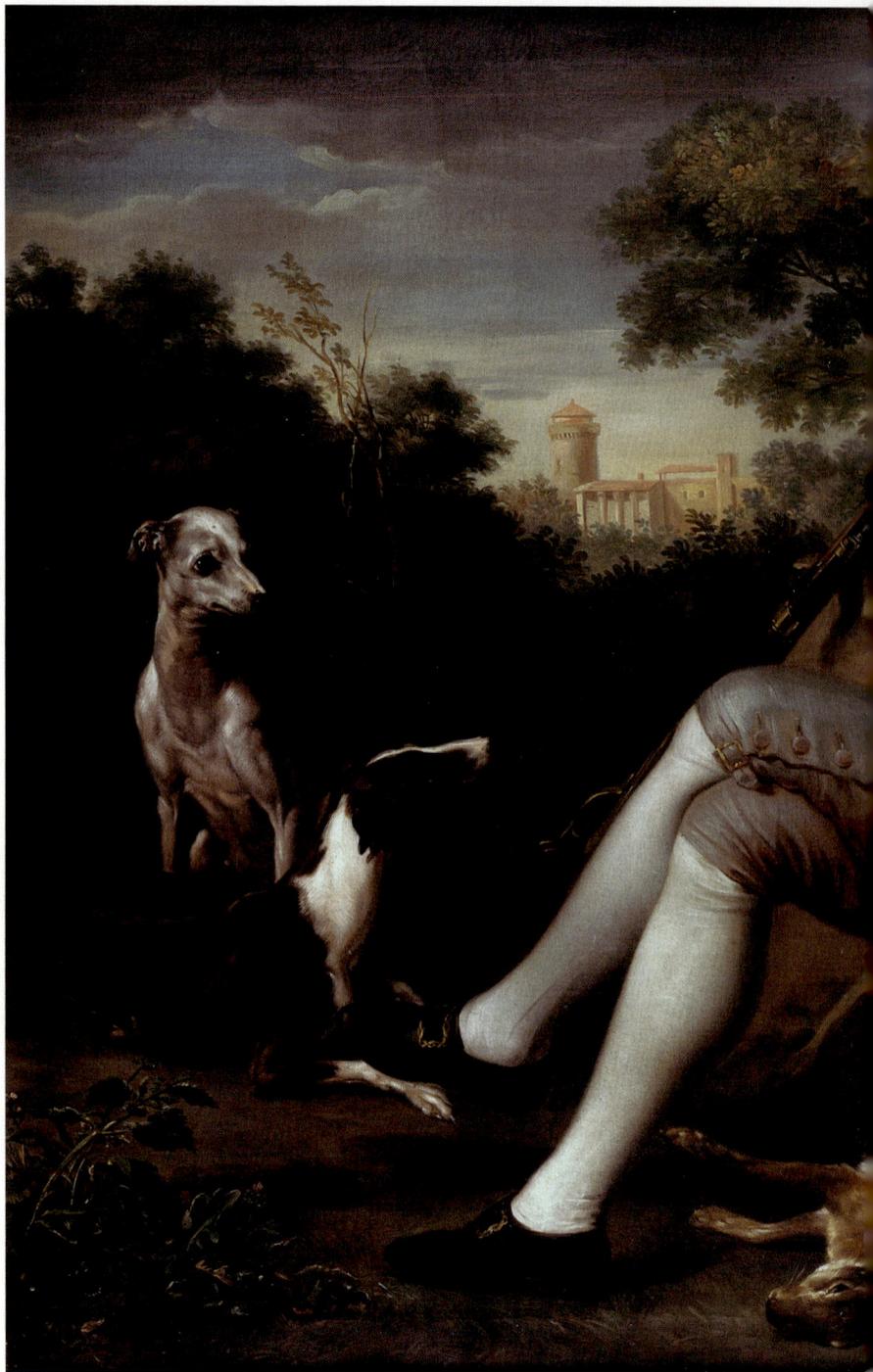

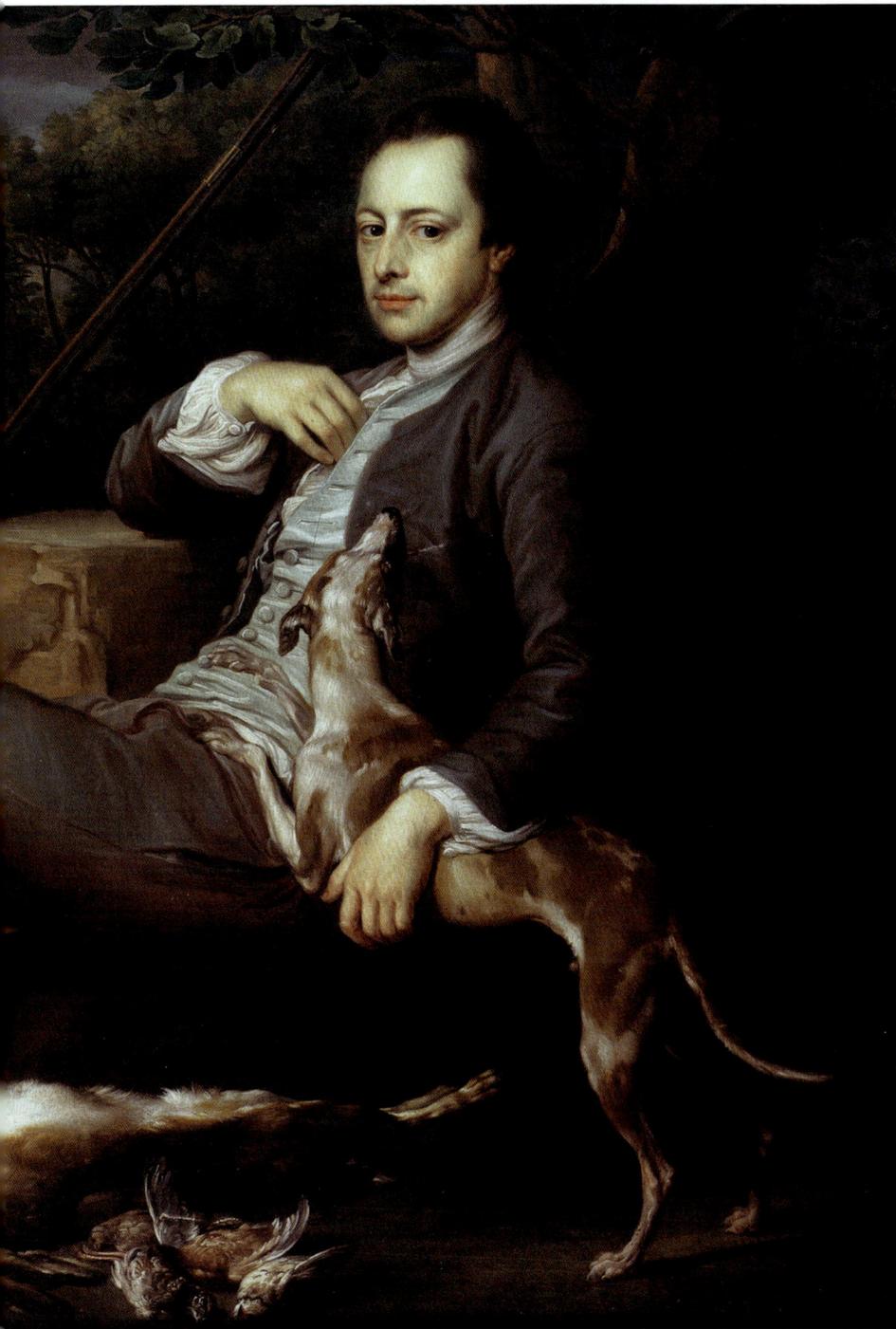

267114

The Grand Tour

During the eighteenth century, rich young Britons often finished their education by touring the Continent. They usually took in the historic cities of Italy, especially Rome, where they could study the greatest works of classical, Renaissance and Baroque art at first hand. For some, it was merely an excuse for a drunken binge, satirised by Thomas Patch (267120, p.30); but others, like Humphry Morice (267114, p.14), took the journey more seriously. They refined their critical faculties with the help of *ciceroni* (tour guides) like Henry Lyte (267117, p.28). They sat for portraits by Pompeo Batoni and Anton Raphael Mengs in Rome. During their travels, they also acquired landscape paintings, classical sculpture and furniture from dealers such James Byres (267119, p.36) to decorate their homes back in Britain and to remind them of Italy.

LOUIS-GABRIEL BLANCHET (1705–72)

267139 *The Arch of the Pantini (Swamps) in the Walls of Augustus' Forum, with, beyond, the Columns of the Temple of Mars Ultor*
Black chalk heightened with white on grey [faded from blue] paper, 25 × 39.5 cm

267140 *The Eight Columns of the Temple of Saturn*
Black chalk heightened with white on grey [faded from blue] paper, 24.8 × 41.9 cm

267141 *A Gateway in the park of a Roman Villa*
Black chalk heightened with white on grey [faded from blue] paper, 26.7 × 41.3 cm

267142 *The Ponte Molle*
Black chalk heightened with white on grey [faded from blue] paper, 23.2 × 40.7 cm

267143 *Umbrella Pine Trees*
Black chalk heightened with white on grey [faded from blue] paper, 40 × 25.5 cm

Blanchet was a French painter and draughtsman who studied at the French Academy in Rome, where he was encouraged to make drawings in black chalk on coloured paper of the sights of the city. These five drawings came from a single sketch book, since dismantled. Blanchet stayed on in Rome after winning the Prix de Rome in 1727. He earned his living as a portraitist, but also produced grisaille paintings of the Apollo Belvedere and other famous classical statues (Saltram, Devon; NT 872541). The immediacy and spontaneity of his style appealed to connoisseurs.

The Blanchets were displayed in Lady Ford's Sitting Room at Wyndham Place, which had a strong 'Rome' theme.

267140

267141

267143

267142

GIOVANNI BATTISTA BUSIRI (1698–1757)

267121 *The Campo Vaccino, Rome*

Gouache, 26.7 × 48.9 cm

267122 *The Colosseum and the Arch of Constantine, Rome*

Gouache, 26.7 × 49.4 cm

267123 *Hadrian's Tomb, or Castel Sant' Angelo, Rome*

Gouache, 22.7 × 33.8 cm

267124 *The Basilica of Constantine or Maxentius, Rome*

Gouache, 22.5 × 33.3 cm

267125 *The Pyramid of Cestius, Rome*

Gouache, 22.5 × 33.3 cm

267126 *The South Side of the Palantine Hill, Rome*

Gouache, 22.5 × 33.3 cm

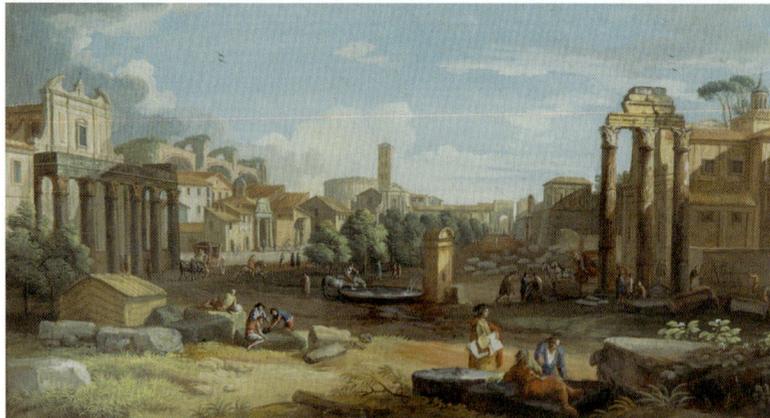

267121

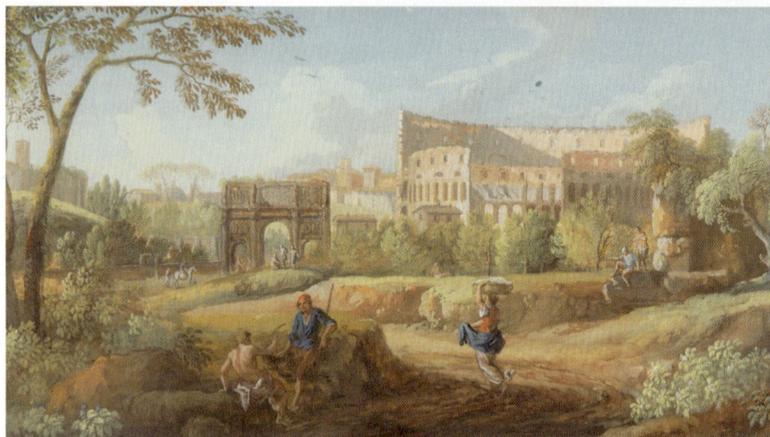

267122

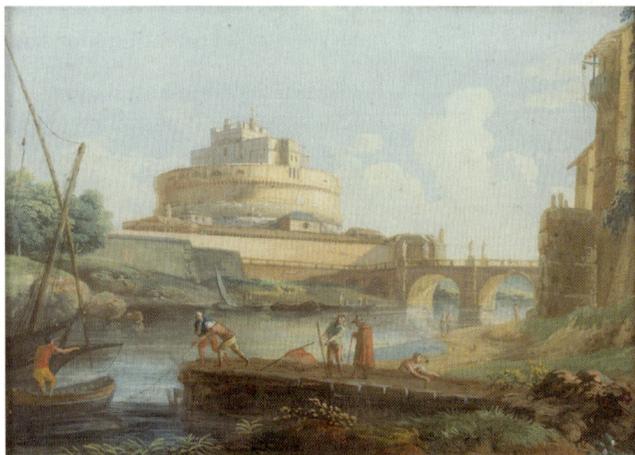

267123

267124

267127 *The Temple of Saturn in an imaginary setting*

Gouache, 22 × 18.3 cm

267128 *The Temple of Caecilia Metella*

Gouache, 24.2 × 18.5 cm

267129 *The Temple of Caecilia Metella*

Gouache, 24.2 × 18.5 cm

267130 *The Forum looking towards the Capitol*

Gouache, 23 × 34 cm

267127

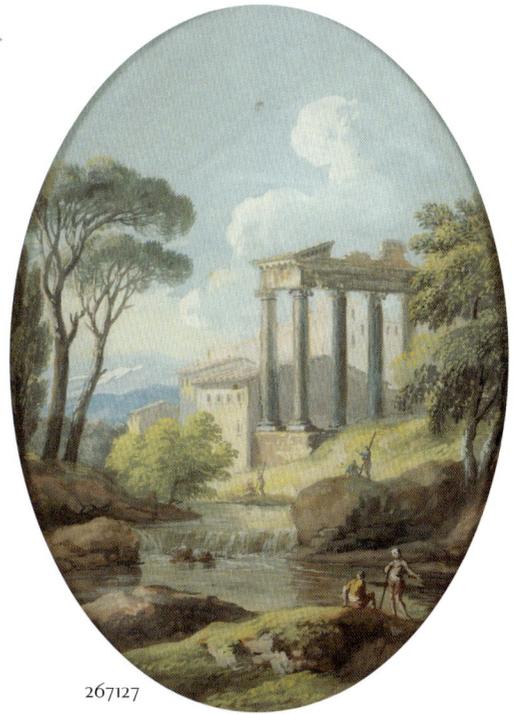

267130

Busiri specialised in small gouaches (opaque watercolours) of views of Rome, which were very popular with Grand Tourists in the 1730s and '40s. Most famously, in Rome in 1739 William Windham bought six large oils and 26 small gouaches by Busiri, which he hung in the Cabinet at Felbrigg in Norfolk, where they remain. Windham's friend Benjamin Stillingfleet called Busiri 'one of the first masters of drawing landscapes with the pen'.

These also hung in Lady Ford's Sitting Room.

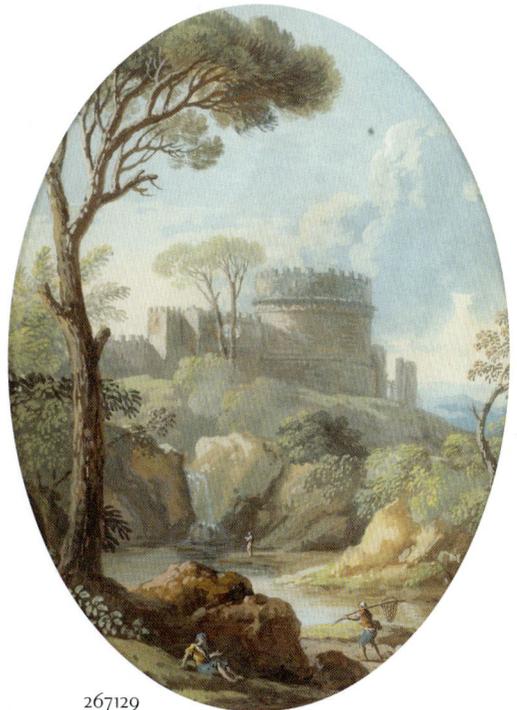

267129

267144 **FRANCESCO CASANOVA** (1732/3–1803)

Woman in a plumed Hat riding a Horse astride, with other Riders, in a Landscape

Pen and bistre on paper, 29.2 × 22.2 cm

The younger brother of the notorious libertine, Francesco Casanova was a much-travelled artist, being active in Paris, Dresden and Austria. This is a rare example in his work of a female rider. It was probably intended to be enjoyed in its own right, rather than to serve as a preparatory study for a painting.

SERAFINO CESARETTI

267131 *A Goat, with the Colosseum beyond*

Bodycolour, 10.8 × 15.2 cm
Signed and dated 1822 on the backing

The goat has been involved in a Bacchic rite. An abandoned thyrsus and cymbals have been painted in the foreground.

267132 *A white Hart, with the Tomb of Caecilia Metella beyond*

Bodycolour, 10.8 × 15.2 cm

In contrast to the Bacchic themes in the picture of the goat, the white hart was a symbol of purity.

Both the Cesarettis hung in Lady Ford's Sitting Room.

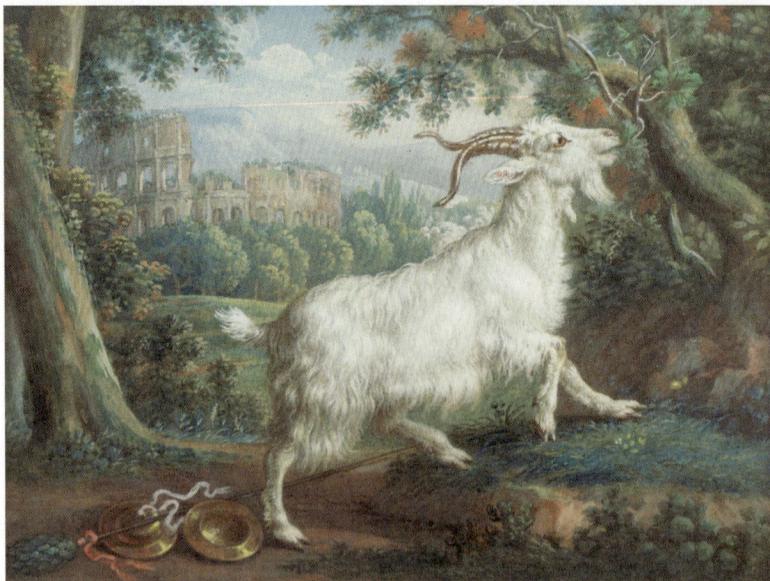

267131

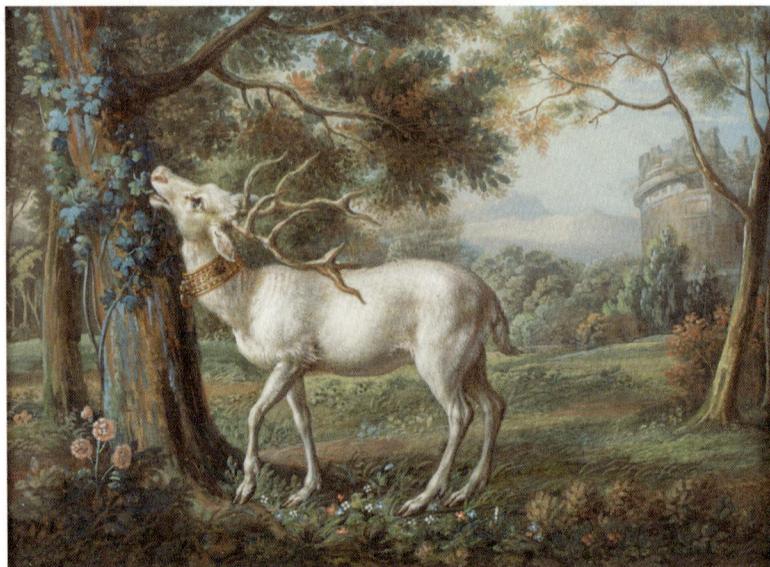

267132

CHARLES-MICHEL-ANGE CHALLE (1718–78)

267145 *Ruins in the Interior of the Colosseum*

Black chalk heightened with white on pinkish paper, 32.5 × 49 cm

Signed on back: *M. a. challe*

267146 *The Tomb of the Plautii near the Ponte Lucano*

Black chalk heightened with white on blue paper, 32.5 × 48.5 cm
Signed, on back: *M. a. challe*

Challe trained initially as an architect, but then studied painting under François Boucher. In 1741 he won the Prix de Rome, which entitled him to study at the French Academy in Rome, where he stayed until 1749, producing chalk drawings in the style of Piranesi. The paintings Challe entered for the Paris Salon were attacked by the influential critic Denis Diderot: 'This Challe brought back from Italy in his portfolio some hundreds of views drawn from nature, in which there is truth and grandeur. Mr Challe, go on giving us your views, but give up painting.' He had more success as a draughtsman with works such as these.

 Also displayed in Lady Ford's Sitting Room.

267146

267147 CHARLES-LOUIS CLÉRISSEAU (?1721–1820)

An architectural Capriccio, 1764

Watercolour and gouache, 59 × 45.1 cm
Signed and dated, lower left: *Clerisseau 1764*

Clérisseau was one of the key creators of the late eighteenth-century Neo-classical style, inspiring the architecture of Robert Adam, Sir William Chambers and Thomas Jefferson. As Alastair Laing has put it, his gouaches and watercolours 'encapsulated, less the Rome that the tourist had seen, than the Rome he would have liked to have seen, or felt that he had seen, once nostalgia had taken the place of memory.' A strikingly similar *Architectural Capriccio* by one of Clérisseau's mentors, Giovanni Paolo Panini, hangs in the Library at Basildon (NT 266897).

267147

267162

267165 ALEC COBBE (b.1945)

Brinsley Ford in the Library at Wyndham Place
(illustrated on p.8)

Oil on board, 52.4 × 30.8 cm

The walls of this room were devoted to Venetian art, including a group of *Punchinello* drawings by Domenico Tiepolo. The painter, designer, conservator and pianist Alec Cobbe is the late Lady Iliffe's nephew-in-law and painted three of the ceiling roundels in the Dining Room at Basildon. He is the National Trust's tenant at Hatchlands Park in Surrey, which he has transformed with generous loans from his collections of paintings and keyboard instruments.

267162 Attributed to ROBERT CRONE (c.1718–79)

Italian Composition. Lake with Ruin

Black chalk and stump, heightened with white, on grey paper, 28 × 40.7 cm

An Irish landscape painter and collector, Crone trained in Dublin. In 1755 he arrived in Rome, where he studied further with Richard Wilson (267105, p.38) and John Plimmer (267161, p.34). While in Rome he lodged with the painters James Forrester (267154, p.24) and L.G. Blanchet (267139, p.16). The traveller James Martin praised him as 'a most excellent Drawer of Landskip of which he has done several for the King. They have a remarkable soft mellowness in them which is very pleasing. He is Irish and does Honour to his Country not only as a fine Painter but as a very Honest Man.' Displayed in Sir Brinsley's Study in 1952.

267155 PHILIPPE-JACQUES DE LOUTHERBOURG
(1740–1812)

Bonoro's Cell, a Scene from David Garrick's
'A Christmas Tale' (Part II, end of Scene I), 1773–4

Pencil, pen and sepia, 23 × 31 cm

De Loutherbourg made his reputation as a master of dramatic theatrical effects with David Garrick's *A Christmas Tale*, which opened at the Theatre Royal, Drury Lane, on 27 December 1773. According to W.T. Parke, it was in this play that De Loutherbourg first introduced 'his newly invented transparent shades, which by shedding on them [the scenes] a vast body and brilliancy of colour produced an almost enchanting effect.'

The drawing shows the climax of Part II, when the squire Tycho falls asleep and drops his magic wand. At once the evil spirits, whom he is supposed to be guarding, break free from their cells in a cacophony of yells and howls.

267155

267154 JAMES FORRESTER (1730–76)

Ariccia, the Chigi Palace and Santa Maria del Assunzione

Pen and ink and wash on blue-grey paper, 27.6 × 36.6 cm

Ariccia lies in the picturesque region of the Campagna south-east of Rome. Famous for its wooded groves sacred to Diana, goddess of hunting, it attracted landscapists such as Forrester and Wilson (267105, p.38). In 1661 it was acquired by the Sienese Chigi family, who commissioned the Palazzo Chigi (on the skyline to the left) and the domed church of Santa Maria del Assunzione (on the right). Both were designed by Bernini, who did much work in St Peter's for the Chigi pope Alexander VII (d.1667).

Having trained in Dublin, Forrester arrived in Rome in 1755, where he lived for the last twenty years of his life, working as a landscape painter, etcher, dealer and drawing master. He lodged for a time with the painters Robert Crone (267162, p.22) and L.G. Blanchet (267139, p.16).

267149 FRENCH SCHOOL, eighteenth-century

An architectural Capriccio

Pen and grey washes with blue watercolour, 41.5 × 57.5 cm

Probably by a French artist inspired by the architectural fantasies of Piranesi.

267154

267149

267150 FRENCH SCHOOL, eighteenth-century

Figures disporting among Classical Ruins

Pen and ink and sepia wash, 21 × 16.3 cm
Signed and dated (erroneously at a later date),
bottom centre: *1799 J.V.B.* [?]

The initials 'J.V.B.' refer to Jean-Victor Bertin
(1767–1842), but it is not by him. More probably
the work of a French student of architecture at
the French Academy in Rome. The drawing is
actually datable to around 1770/80.

267106 AUGUSTUS JOHN (1878–1961)

Brinsley Ford (1908–99), 1941
(illustrated on p.1)

Pencil, 67.2 × 51.2 cm

One of five portraits of Sir Brinsley drawn by
John in 1941. The sitting took place on the
afternoon of 30 October in the artist's Tite
Street studio, as Sir Brinsley describes: 'He then
started on a profile of me puffing at his cigar and
I at mine. After what seemed a very short time,
perhaps 20 minutes, he got up and told me to
have a look. The drawing seemed to have been
blown onto the paper with the cigar smoke and
to have caught the slight alcoholic flush on my
nose. John had drunk a great deal at lunch but
still he was able to produce this very sensitive
portrait.'

 John's pencil sketch of Lawrence of Arabia
(Shaw's Corner, Hertfordshire; NT 1274660) is
another fine example of his skill as a
draughtsman.

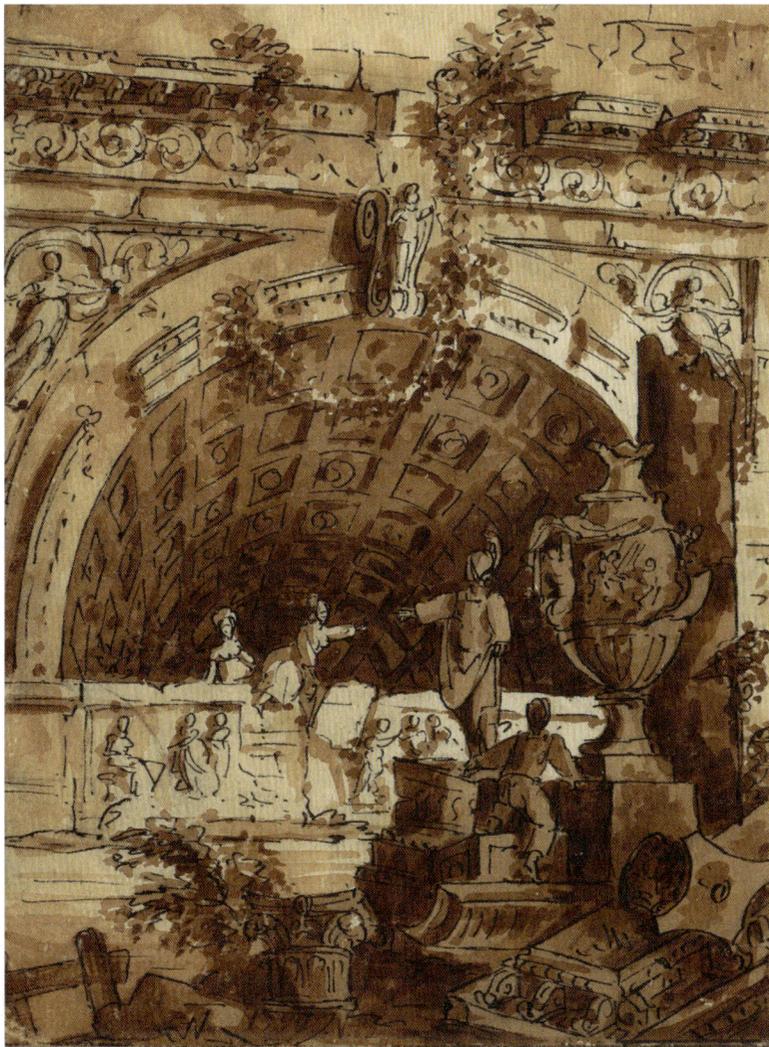

267150

267163.1–6 ABBÉ DE SAINT-NON (1727–91) after JEAN-BAPTISTE LE PRINCE (1734–81)

Set of six Views of Roman Monuments

Engravings, 36 × 31 cm

Le Prince is said to have visited Italy in 1754, in flight from his much older wife. By 1757 he was in Russia, where he spent most of his career. Saint-Non visited Rome in 1759 and travelled widely in Italy. Saint-Non devoted most of his energies to producing engravings after Italian views by Le Prince and many other artists.

GODFRIED MAES (1649–1700)

267151 *Princely Splendour (Princen Heerlyck-heydt)*

Pen and brown ink with grey wash and watercolour, 8.9 × 10.4 cm
Signed, lower left: *G. Maes* and inscribed, lower centre: *Princen Heerlyck-heydt*

267152 *Fortitude (Sterckte)*

Pen and brown ink with grey wash and watercolour, 8.9 × 10.4 cm
Signed, lower left: *G. Maes* and inscribed, lower centre: *Sterckte*

PAUL MAITLAND (1863–1909)

267109 *?The River above Battersea Bridge*

Oil on panel, 24.7 × 24.7 cm
Signed, below left: *PM*

267110 *A Chelsea Street*

Oil on panel, 23.5 × 14.6 cm
Signed, lower right: *PM*

267111 *Riverside*

Oil on panel, 15.2 × 13.4 cm
Signed lower right: *P.M.*

Maitland trained at the Royal College of Art and was influenced by Whistler, whose fascination with the Thames and subdued grey-brown palette he shared. Back problems restricted his mobility, and so he concentrated on painting mainly small-scale views of Kensington and Chelsea near where he lived.

267163.1

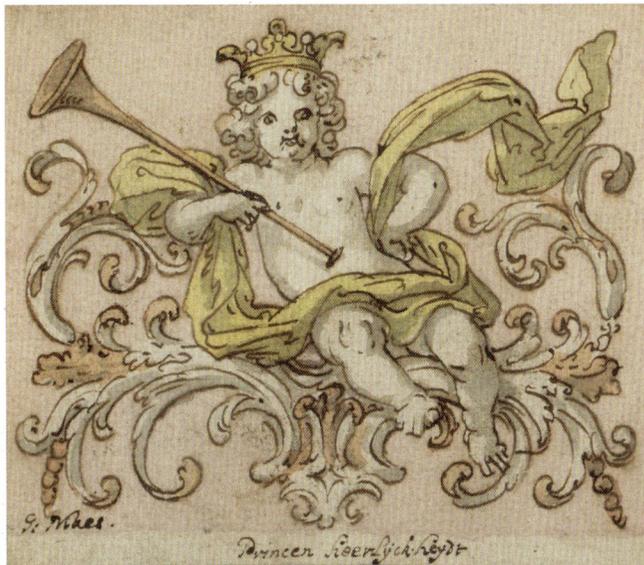

267151

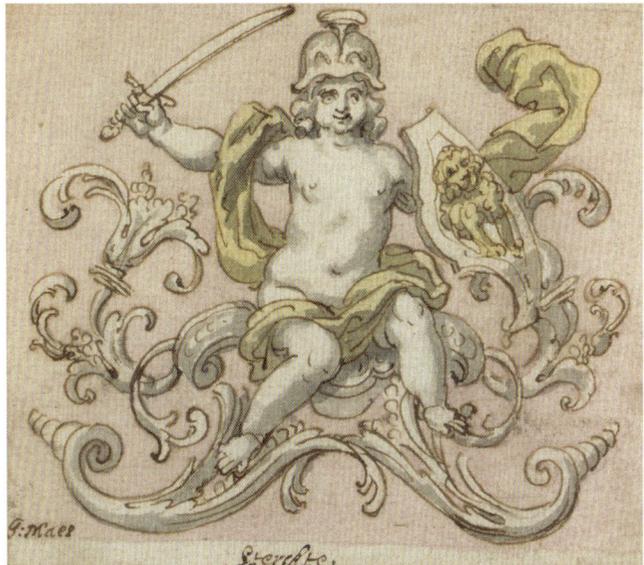

267152

267133 MARCO MARCHETTI DA FAENZA
(before 1528–88)

Design for a Decoration

Pen and brown ink with brown wash on paper,
26.8 × 19.5 cm

Marchetti specialised in grotesque decoration of
this kind. He spent most of his later years in
Rome, where he painted the Loggie of Pope
Gregory XIII (1572–85). This was probably
designed for a temporary structure with an
allegorical meaning.

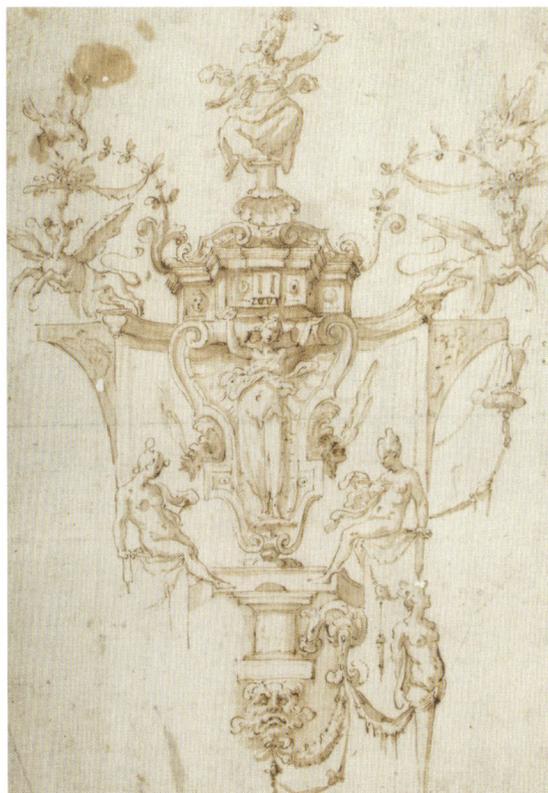

267133

267117 **ANTON RAPHAEL MENGS** (1728–79)

Henry Lyte (1727–91), 1758

Oil on canvas, 97.8 × 73.6 cm
Inscribed, lower right, by a later hand: *Henry Lyte Esqr. Sub Preceptor and Master of the Rolls and Privy Purse H.R.H. the Prince of Wales, afterwards George the 4th and Auditor of the Duchy of Cornwall Died 1791 By Raphael Mengs*

Lyte may have been a descendant of the botanist and antiquarian Henry Lyte (*c.* 1529–1607) of Lytes Cary, Somerset (NT). He sat to Mengs in Rome in 1758, while he was acting as tutor to the 17-year-old John, Lord Brudenell, who was painted full-length by Mengs at the same time. Lyte's portrait may have been a thank-you present for getting Mengs the Brudenell commission. Lyte was a fellow of Queen's College, Cambridge, and is depicted as a bookish scholar. Robert Adam, who met Lyte in Genoa, described him as 'a clever-like fellow'. Lyte exported marbles, bronzes and small tables from Rome.

Sir Brinsley bought this picture at Sotheby's in 1953 for only £25, plus £5 dealer's commission to Colnaghi's.

Mengs painted the 1st Marquess of Londonderry about 1758 (Mount Stewart, Co. Down; NT 1220974) and George Harry, Lord Grey (later 5th Earl of Stamford) in 1760–8 (Dunham Massey, Cheshire; NT 932353).

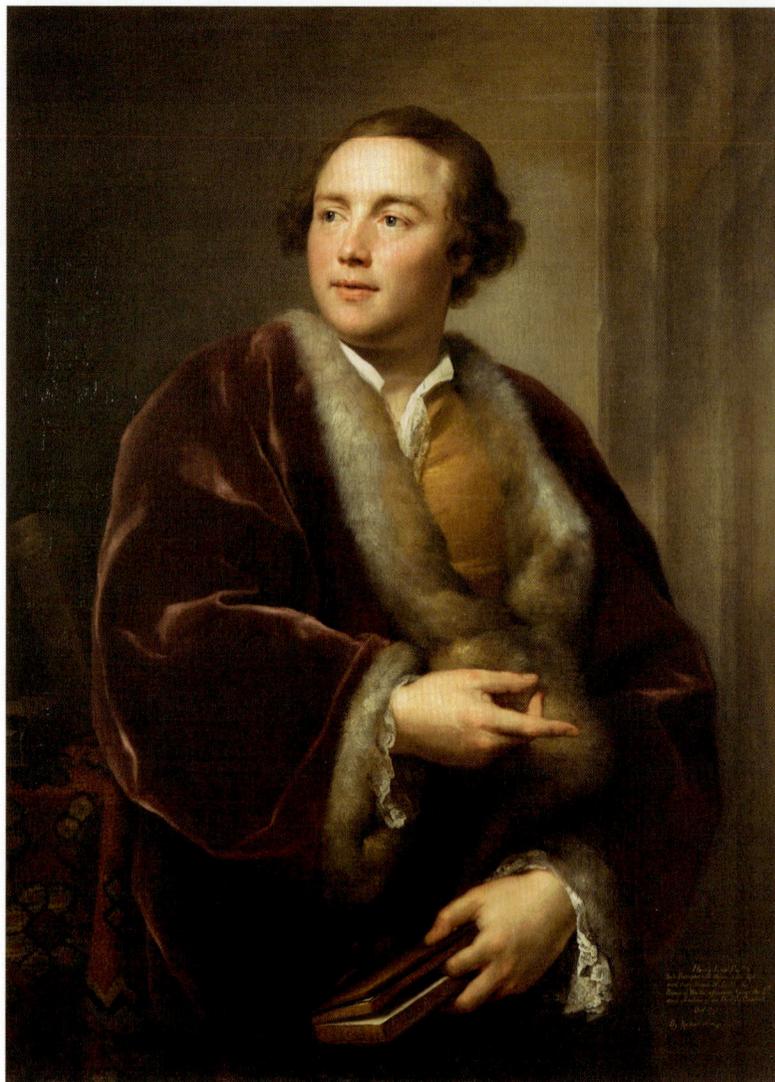

267117

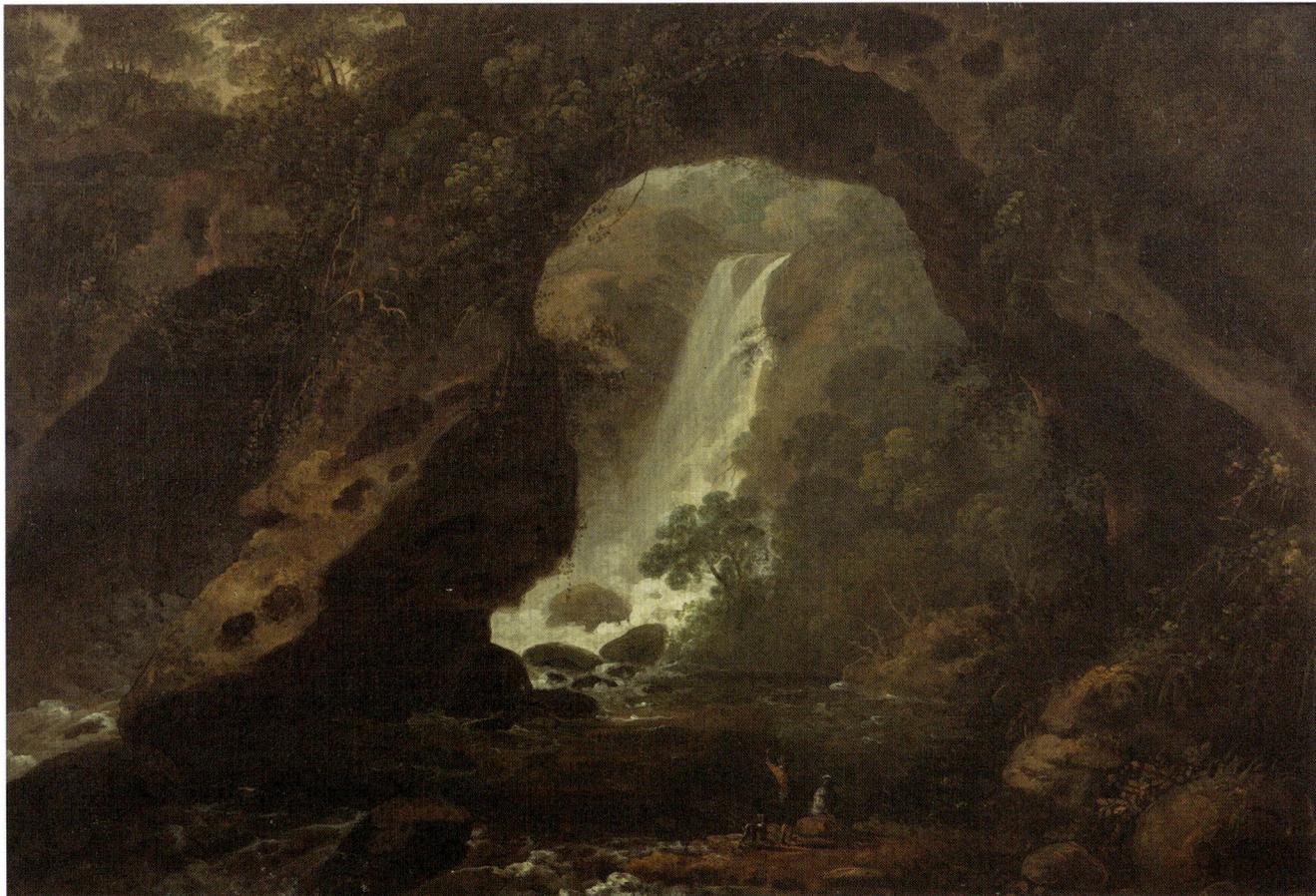

267166

267166 Attributed to JACOB MORE (1740–93)

Neptune's Grotto at Tivoli

Oil on canvas, 41 × 62.5 cm

Trained in Edinburgh, More settled in Rome about 1773, where he lived for the last 20 years of his life. His atmospheric landscapes of Italy won high praise. Joshua Reynolds described him as 'the best painter of air since Claude'. In 1784 he presented a full-length self-portrait to the Uffizi's famous collection of artists' self-portraits in Florence. More showed himself painting in front of Neptune's Grotto at Tivoli, a popular subject, which he depicted many times. He also acted as a dealer and agent for the Earl-Bishop of Bristol, who commissioned at least fourteen pictures from him. The only survivor at Ickworth in Suffolk (NT) is *Ideal Classical Landscape with Cicero and Friends*, painted in 1780 (NT 851984).

267120 THOMAS PATCH (1725–82)

A Gathering of Dilettanti around the Medici Venus,
c.1760

Oil on canvas, 137.2 × 228.6 cm

Patch is best known for his caricatures of British
Grand Tourists amid the masterpieces of Italy.
He lived in Florence from 1755 until his death. The
gallery setting is imaginary, but the five
sculptures from the Medici collections in
Florence are identifiable: (left to right) the
Wrestlers, the *Mercury*, the *Venus de' Medici*, the
Dancing Faun and the *Arrotino* (*Knife-grinder*).
Patch depicts himself clambering up the *Venus
de' Medici* to measure with callipers the distance
between her nose and wrist. (Patch took a
serious interest in physiognomy.) Most of the
milordi seem more interested in socialising than
in the Medici treasures. Many private jokes are
contained in the picture, but they are now, sadly,
lost to us. The painting was cut into four to form
a screen when it was bought by Sir Brinsley.

Similar caricatures by Patch are to be found at
Dunham Massey in Cheshire (NT 932354, 932359)
and Petworth in Sussex (NT 486255).

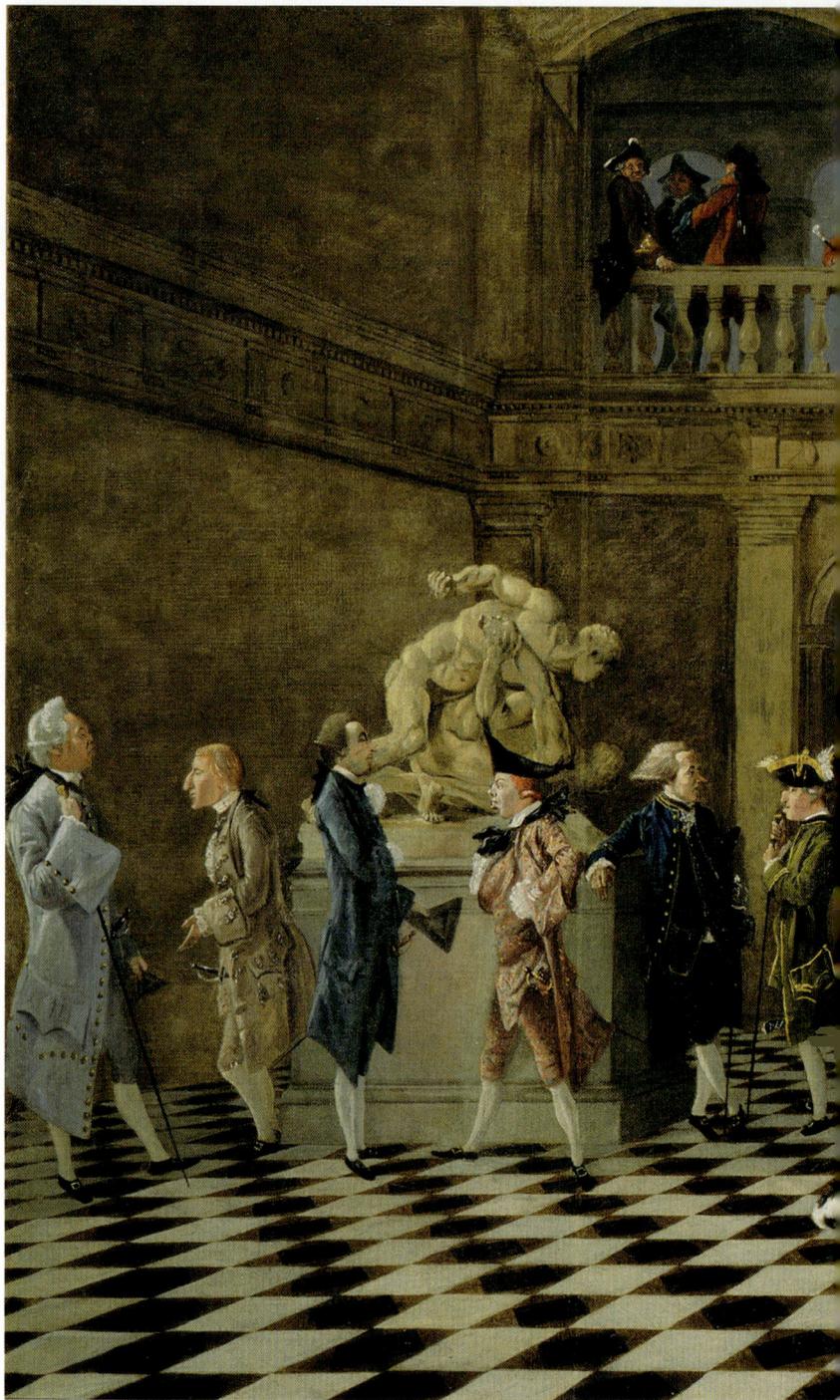

267120

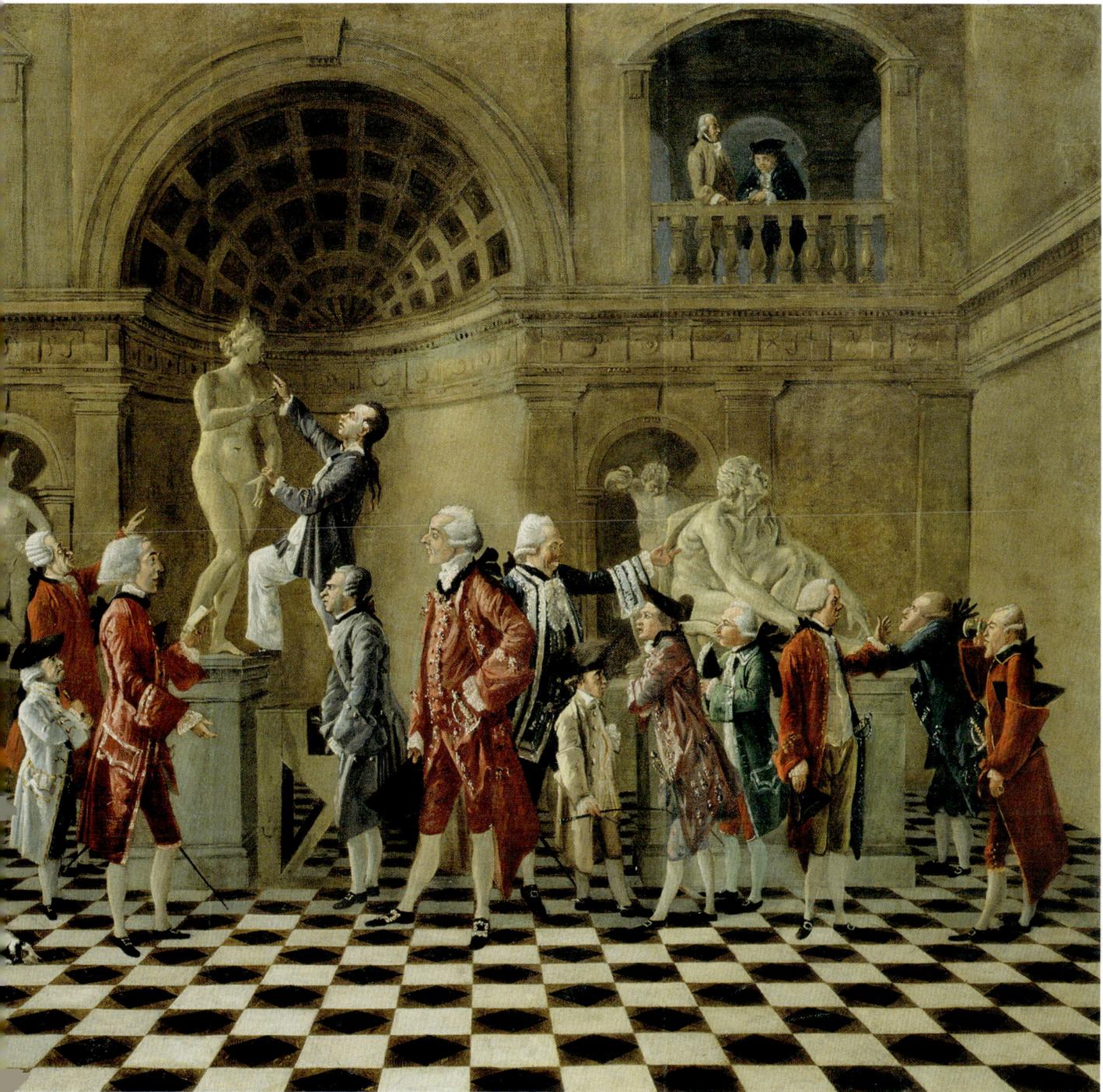

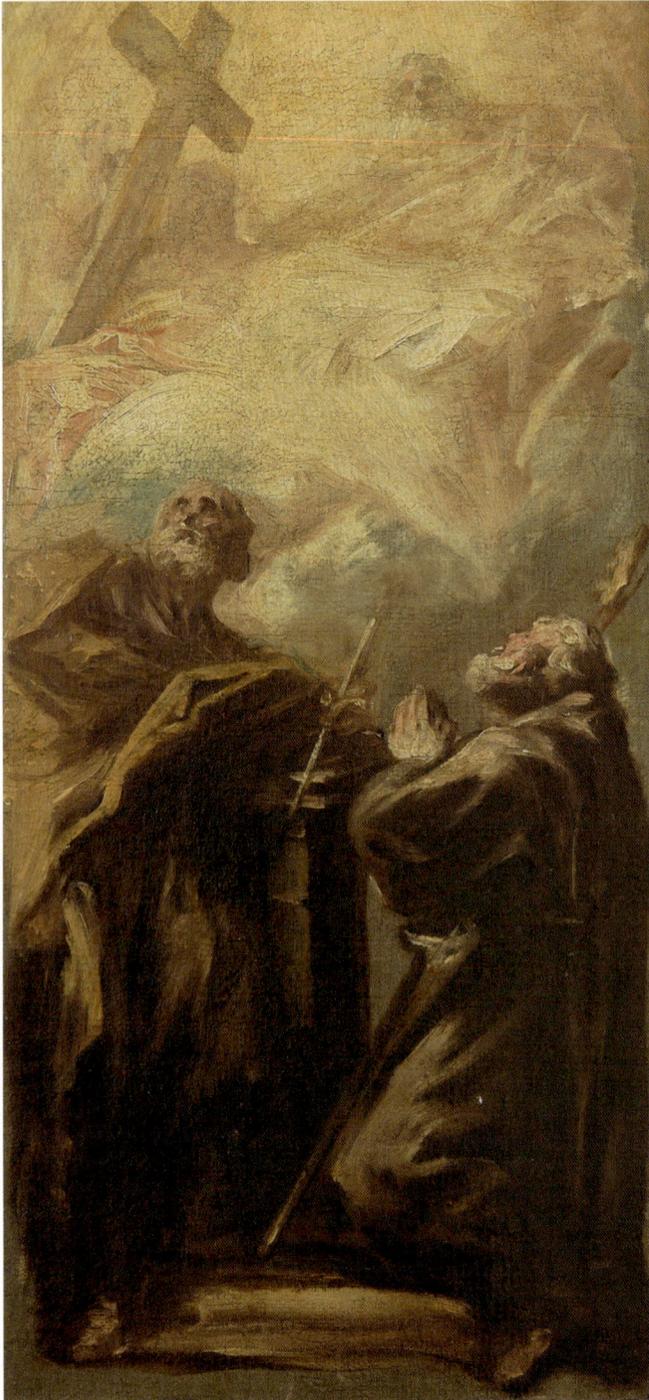

267115 GIOVANNI ANTONIO PELLEGRINI (1675–1741)

The Holy Trinity with SS Joseph and Francesco di Paola, 1727

Oil on canvas, 56 × 28 cm

Sketch for the altarpiece of the same subject in the church of San Vidal in Venice. Pellegrini was the first, and one of the finest, Venetian decorative painters to work in Britain in the eighteenth century. In 1708 he was invited by the 4th Earl of Manchester (then British Ambassador in Venice) to decorate Kimbolton Castle in Huntingdonshire with frescoes of musicians (the Earl was a great lover of Italian opera). Pellegrini left England for Düsseldorf in 1713.

Sir Brinsley's fascination with Italian eighteenth-century art was shared by his close friend Ralph Dutton (later 8th Lord Sherborne), who bought Pellegrini's titillating *Susannah and the Elders* and *Diana and Endymion* (both Hinton Ampner, Hampshire; NT 1530089, 1530088) in 1961, when art of this kind was starting to come back into fashion.

267115

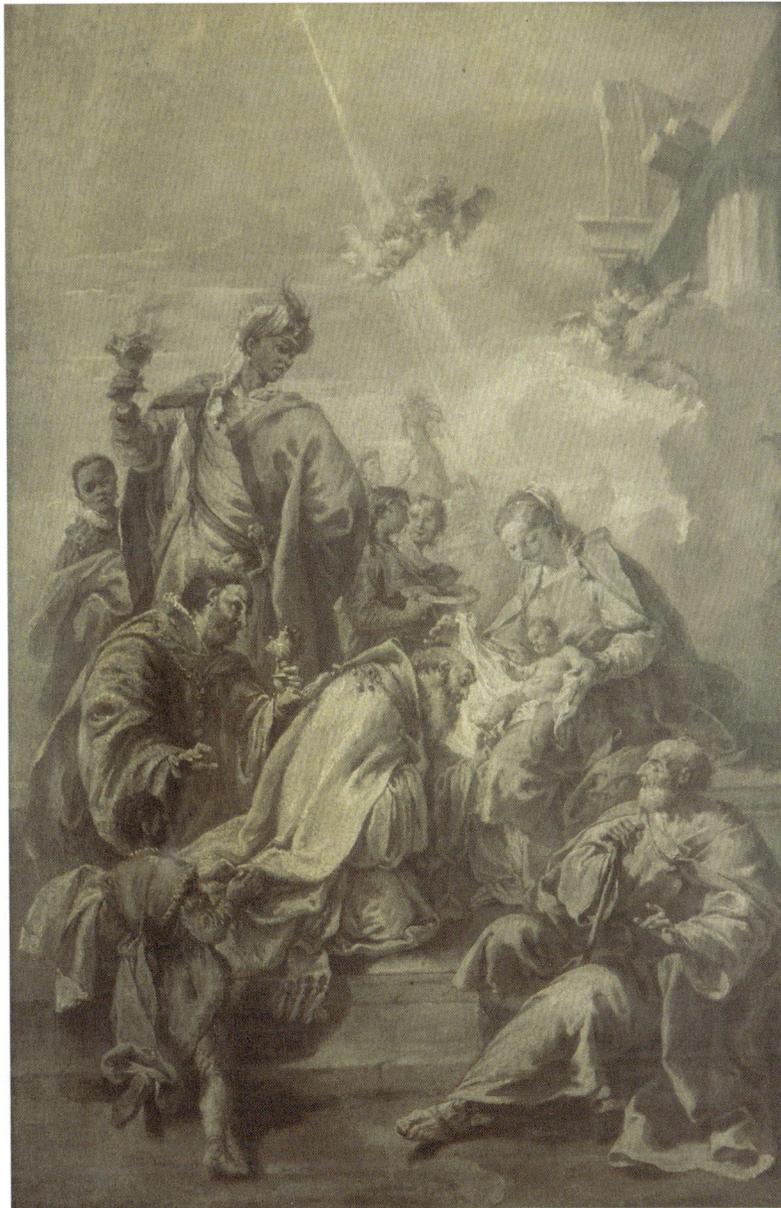
267116

267116 GIOVANNI BATTISTA PITTONI (1687–1767)

The Adoration of the Kings, c.1740

Oil on canvas, 67.3 × 45.7 cm

A *grisaille* (monochrome) *modello* (preparatory study) for an altarpiece painted in 1740 for the church of SS Nazaro and Celso in Brescia. The composition was inspired by Veronese's *Adoration* of 1573 from San Silvestro, Venice (now National Gallery, London). This in turn was indebted to Dürer's woodcut of the *Adoration*, 1501–2.

Pittoni was a leading exponent of the Venetian Rococo style. He was a particularly fine draughtsman, and preparatory studies of this kind often have a freedom not seen in his finished work. Basildon Park already displays no fewer than three major paintings by Pittoni: *Cleopatra and the Pearl*, *The Death of Lucretia* and *Mars and Venus* (NT 266903, 266908, 266913).

267118 JOHAN GEORG PLATZER (1704–61)

The Feast of Flora
(illustrated on p.11)

Oil on copper, 55.2 × 74.3 cm

Born into a family of painters in the South Tyrol, Platzer came to study in Vienna after 1726. Influenced by the Hapsburg collections in Vienna, he decided to settle here. Platzer specialised in painting on copper. Copper plates were much used for book-printing and engraving, but had also been popular as a painting support since the early seventeenth century, because they were smooth, rigid and durable. They were particularly suitable for small, highly finished 'cabinet' pictures. Platzer worked on an unusually large scale and kept the tradition alive into the second half of the eighteenth century.

Displayed above the fireplace in the Drawing Room.

267161 Attributed to JOHN PLIMMER (*c.*1725–60)

View of Rome from the Grounds of the Villa Madama

Black chalk, heightened with white on grey paper, 35 × 52.8 cm

An Irish landscape painter, Plimmer was in Rome between 1755 and his premature death in 1760, where he studied with Richard Wilson. Wilson painted a similar view, the prime version of which, dated 1753, is in the Yale Center for British Art, New Haven, CT. In 1759 Thomas Jenkins praised Plimmer to Henry Hoare of Stourhead in Wiltshire (NT) as 'without comparison the best Landskip painter we have at this time in Italy'. Hoare was encouraged to commission Plimmer to copy Claude's *Procession to the Temple of Apollo at Delos*. The copy is still at Stourhead (NT 732178).

 Hanging in Sir Brinsley's Study in 1952.

267161

267148 Manner of HUBERT ROBERT (1733–1808)

View of a Villa with Steps leading up to a Terrace

Pen and wash, 24.7 × 30.5 cm

The view is probably imaginary, but it has some similarities with the precipitate flights of stairs found in the *palazzi* of Genoa. Robert studied from 1754 to 1765 in Italy, which stimulated his fascination with depicting architecture (often ruined) in landscape settings.

267148

267136

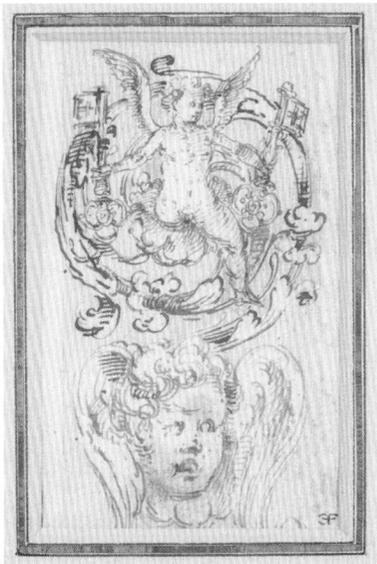

267137.1

267137.2

267138

ROMAN SCHOOL, late sixteenth-century

267136 *A Putto holding the Papal Tiara and the Buoncampagno winged Dragon*

Pen and brown ink, 19.7 × 7.3 cm

267137.1 *A Putto holding the Papal Keys and a Cherubim*

Pen and brown ink, 11.5 × 7 cm

267137.2 *A Frieze with a dancing Goat and a Hunter with a Spear*

Pen and brown ink, 7 × 11.5 cm

The papal tiara and keys and the dragon of the Buoncampagno family suggest that these drawings may relate to a decorative scheme commissioned by Gregory XIII (Pope from 1572 to 1584).

These three drawings were displayed above the fireplace in the Drawing Room.

267138 ROMAN SCHOOL, *c*.1700

Design for a Candlestick, with Faith and another Figure below

Pen and brown ink, grey wash on paper, 19 × 6.9 cm

267119 FRANCISZEK SMUGLEWICZ (1745–1807)

The Byres Family, c.1776–9

Oil on canvas, 33 × 39.4 cm

For three decades from the 1760s, the Scottish *cicerone* (tour guide), dealer and antiquary James Byres (1734–1817) was a familiar figure among British visitors to Rome. In 1778 Philip Yorke (later 3rd Earl of Hardwicke) of Wimpole Hall in Cambridgeshire (NT) recorded how Byres varied his sightseeing programme according to the weather: 'Antiquities and ruins when fine, statues and palaces when wet, and if it should be a clear day but unpleasantly windy we see pictures.' Byres is shown standing behind a chair on the left, talking to his sister Isabella. Byres's mother Janet is seated in the centre. His father Patrick is standing in a green suit. On the right is Byres's business partner, Christopher Norton, in a red suit. The dome of St Peter's is visible in the background.

267119

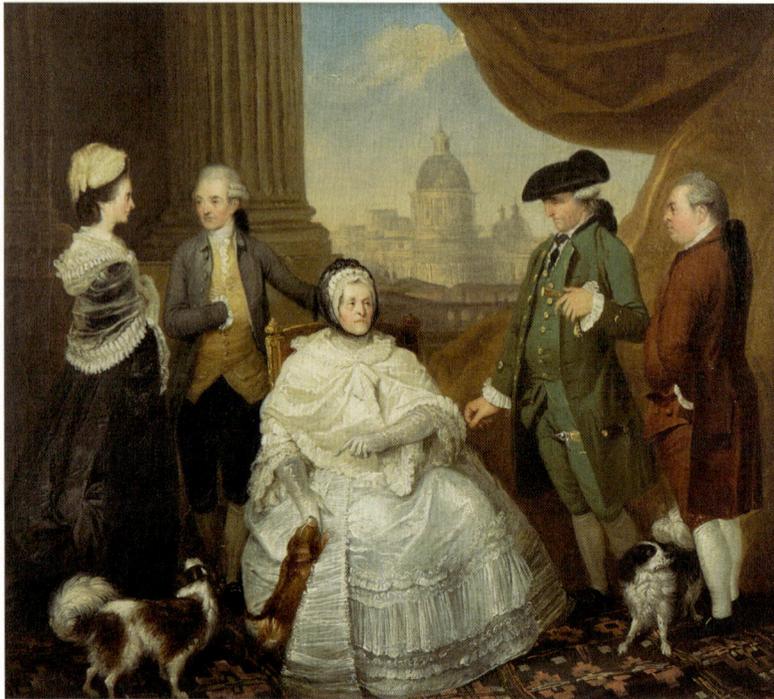

Byres also appears in conversation-pieces attributed to the Scottish painter John Brown (1752–87) (versions at Springhill, Co. Londonderry; NT 216386; and Ham House, Surrey; NT 1139726).

GIOVANNI DOMENICO TIEPOLO (1727–1804)

267134 *Two Figures on a Balcony*

Pen and brown ink and greyish wash over black chalk on paper, 34.4 × 14.5 cm
Signed, lower right: *Dom. Tiepolo f.*

267135 *Three Figures on a Balcony*

Pen and brown ink and greyish wash over black chalk on paper, 32.6 × 18.5 cm
Signed, lower right: *Dom. Tiepolo f.*

The eldest surviving son of the great Venetian muralist Giambattista Tiepolo, with whom he frequently collaborated, as well as working as an independent painter, draughtsman and etcher. These two delightful pen-and-ink drawings are not preparatory studies, but in fact later records of the fresco cycle at the Villa Contarini at Mira on the Brenta (now Musée Jacquemart-André, Paris), on which Giandomenico may have worked with his father and which was completed by 1750.

These two drawings hung over the fireplace in the Drawing Room.

Evidence of the closeness of father and son is demonstrated by Giandomenico's *The Madonna appearing to SS Anthony of Padua and Francis of Paola* (Upton House, Warwickshire; NT 446822), which was originally attributed to Giambattista.

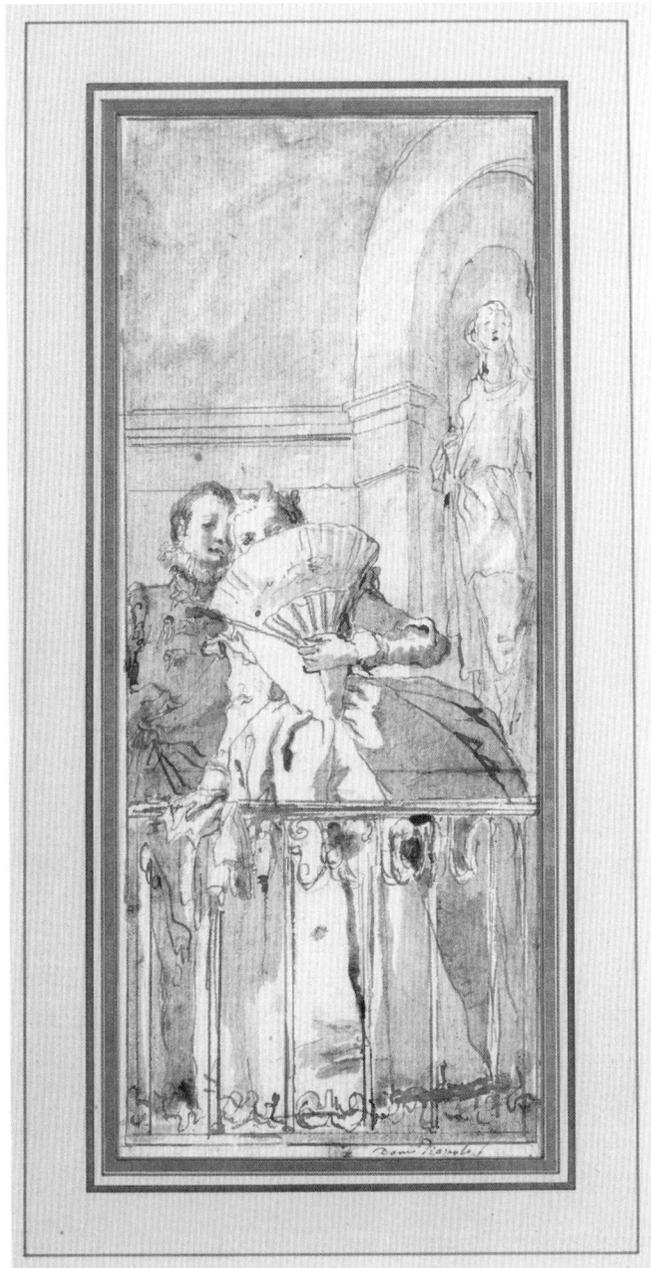

267134

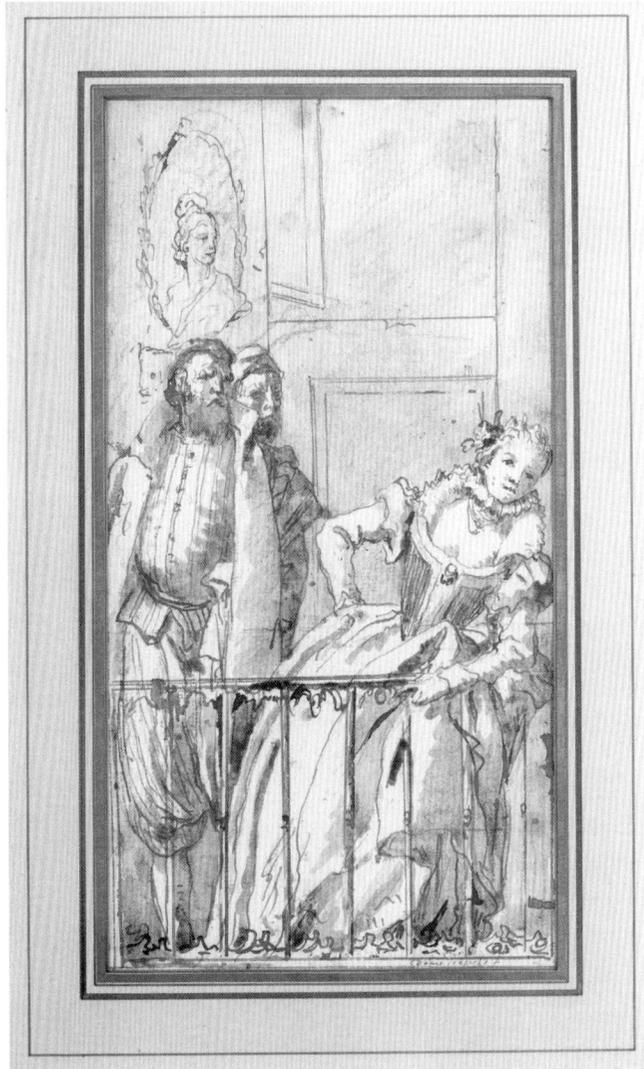

267135

RICHARD WILSON (1713/4–82)

267105 *The Murder*, c.1770

Oil on canvas, 43.2 × 53.3 cm

Grand Tourists were attracted to Italy by the prospect of culture and conviviality, but travel in the eighteenth century had its darker side. The threat of robbery (or worse) was ever present. Wilson also drew on the combination of horrific subject-matter and dramatic landscape that Salvator Rosa had popularised in the seventeenth century.

Wilson toured Italy from 1750 to about 1757, arriving in Rome in late 1751. He rapidly made a reputation among Grand Tourists as a landscape painter in the Claudean style, continuing in this manner on his return to Britain: e.g. *View on the Arno*, c.1760–3 (Petworth, W. Sussex; NT 486176). One of Wilson's most generous patrons in Italy was Ralph Howard (later Viscount Wicklow), who commissioned another version of *The Murder* (now National Museum of Wales, Cardiff).

Displayed in Sir Brinsley's Study in 1952.

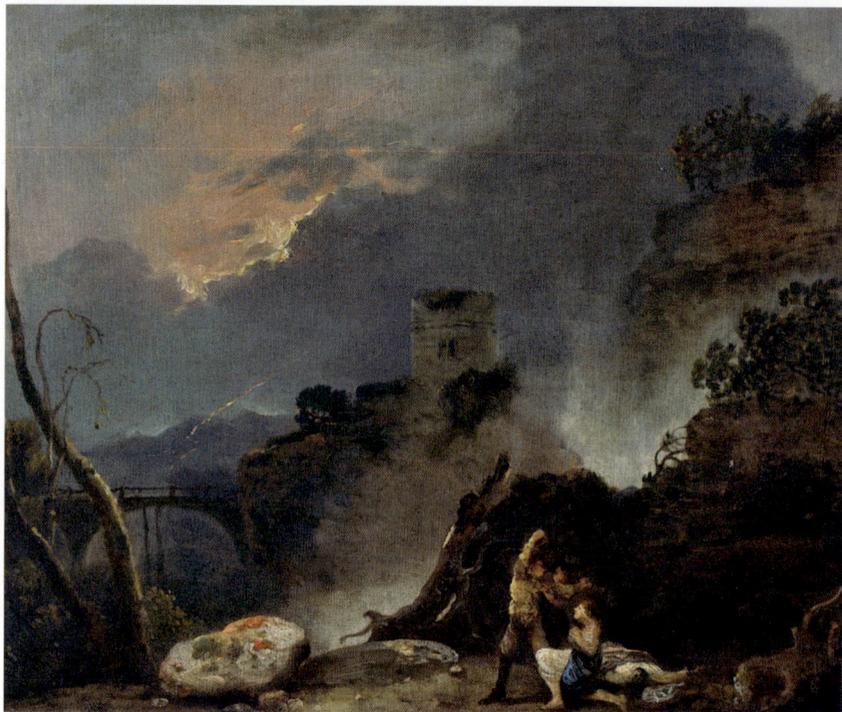

267105

267112 *A Church at Ariccia*, c.1754

Black chalk and stump with white highlights over graphite, 31 × 44 cm
Signed, lower right: *RW*

For Ariccia, see p.24. Sir Brinsley suggested that Wilson produced this drawing in the studio after a sketch made in Italy. The church has not been identified. The drawing's original owner was William Lock of Norbury Park in Surrey (NT), who accompanied Wilson on his journey from Venice to Rome in 1751. Lock is said to have encouraged Wilson to take up landscape painting (Wilson had started out as a portraitist).

Sir Brinsley compiled the definitive catalogue of Richard Wilson's drawings.

267112

Sculpture

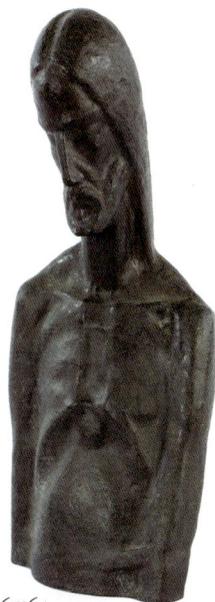

267164

267164 ALBERT BECHTOLD (1885–1965)

Christ

Bronze, 38 cm high

Bechtold was an Austrian sculptor who trained at the Academy of Fine Arts in Vienna. After the First World War he settled in Bregenz on Lake Constance, where he specialised in carving war memorials. Sir Brinsley was on holiday in Bregenz in 1928, when, as he recalled, 'I was so mad to acquire this head that I moved from the good hotel in Bregenz to a cheap pensione in order to save up enough money to acquire it.' Bechtold was sacked from his teaching post in Vienna by the Nazis in 1938.

267158 FRENCH SCHOOL, late nineteenth-century

Une Dévote (A Woman at Prayer)

Terracotta, 31 cm high

This sculpture is distinctly satirical in tone.

267159 WILHELM DE GROFF (1676–1742)

Bust Portrait of Maximilian II Emanuel, Elector of Bavaria (1662–1726)

Lost wax, cast bronze, 17.2 cm high

The Flemish sculptor De Groff trained in Antwerp and Paris. His first certain work was an equestrian statuette of Maximilian dated 1714 (Bayerisches National-Museum, Munich), who was then living in exile in Paris, having commanded the armies of Louis XIV against Britain and her allies. The following year Maximilian was restored to power as Elector of Bavaria. He spent lavishly on his

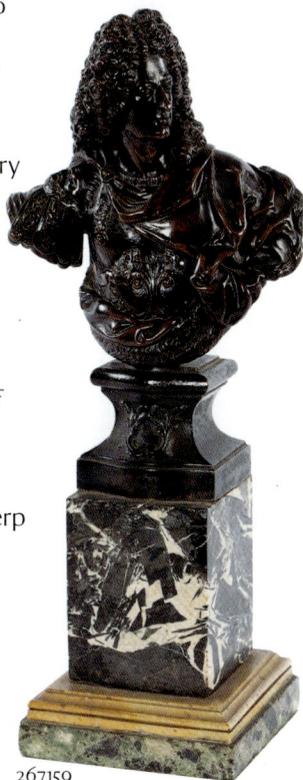

267159

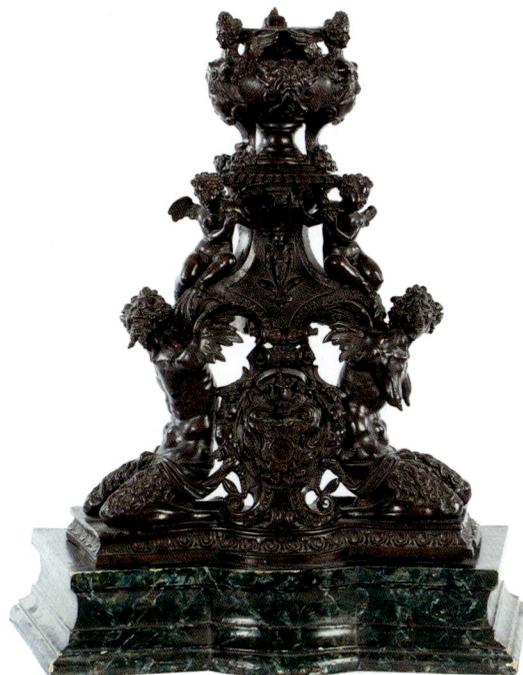

267167 (see p.40)

palaces around Munich, employing De Groff to produce sculptures for the gardens of Nymphenburg and Schleissheim in the court style of Louis XIV.

267160 Probably NETHERLANDISH, seventeenth-century

Tobias holding his Fish

Terracotta, 35 cm high

While bathing in the River Tigris, Tobias is attacked by a giant fish. His companion, the archangel Raphael, tells Tobias to catch and gut the fish, burning the heart and liver to ward off evil spirits.

The adventures of Tobias and Raphael are told in the apocryphal Book of Tobit. The sculpture is a *bozzetto*, which was a 'sketch' for a larger piece.

Furniture

267167 Attributed to NICCOLÒ ROCCATAGLIATA (active 1593–1636)

Andiron incorporating winged and female Satyrs, Putti, Harpies and grotesque masks (illustrated on p.39)

Bronze, 65.5 cm high

This fireplace ornament was cast in Venice, with its pair, for the Palazzo Soranzo, from which they were bought by the 3rd Earl of Bute (1713–92), who travelled in Italy between 1768 and 1771. They were subsequently separated, and this one has lost its crowning statue, which was probably of the goddess Juno. Sir Brinsley managed to acquire this andiron for only £200 in 1965, having expected to pay a great deal more.

267156 After SEBASTIAN SLODTZ (1655–1726)
Hannibal counting the Rings of the Roman Knights killed at the Battle of Cannae

Bronze, 35 cm high

Probably cast in the early 1870s in Paris as a bronze statuette after a large marble figure carved by Slodtz in 1687–1704 (now in the Louvre, Paris).

267157.1–2 After model attributed to JEAN WARIN (1596–1672)

A Pair of Plaques of bearded Sages or Saints

Bronze or copper, 13.3 × 10.8 cm

In the past it has been suggested that they are Saints Peter and Paul.

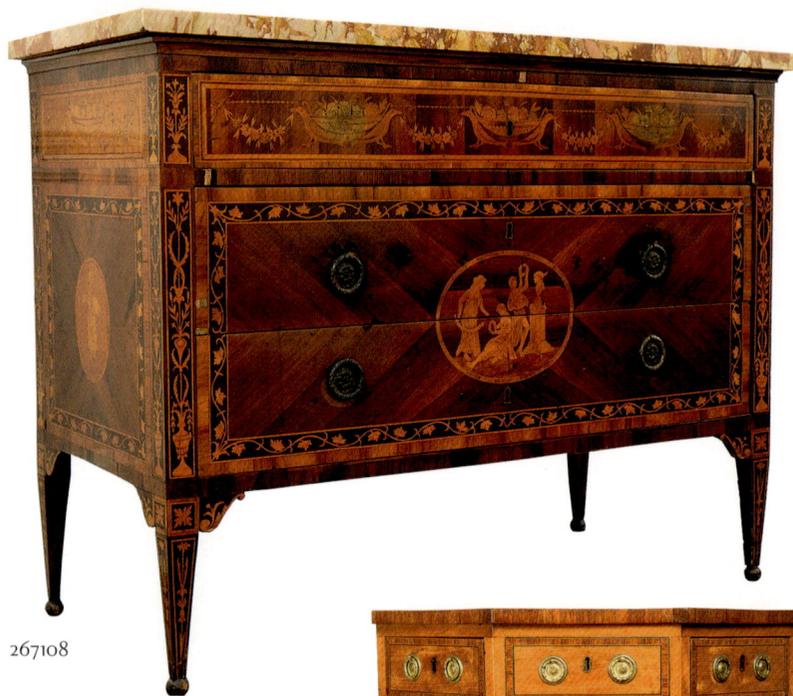

267108

267108 A three-drawer commode with later marble top in the style of Giuseppe Maggiolini (1738–1814). It is inlaid with classical figures and floral motifs. The commode stood in the Ante-room at Wyndham Place.

267107 An eighteenth-century octagonal occasional tripod table, in mahogany inlaid with satinwood.

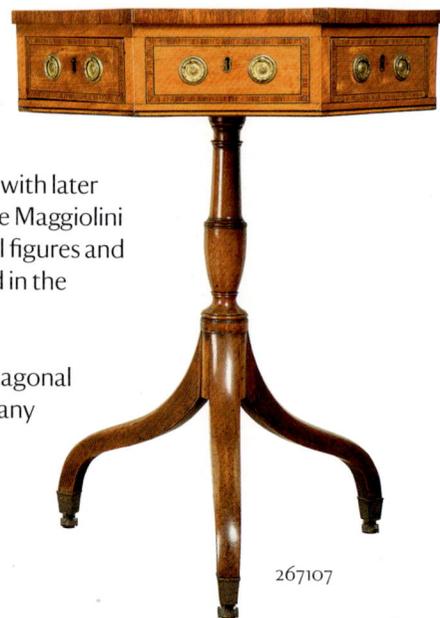

267107